ST AUSTELL
THROUGH TIME
Valerie Jacob

AMBERLEY PUBLISHING

Dedication

To my husband Brian Jacob
who has always loved his home town
and his native Cornwall.

First published 2009

Amberley Publishing Plc
Cirencester Road, Chalford,
Stroud, Gloucestershire, GL6 8PE

www.amberley-books.com

Copyright © Valerie Jacob, 2009

The right of Valerie Jacob to be identified as the
Author of this work has been asserted in accordance
with the Copyrights, Designs and Patents Act 1988.

ISBN 978 1 84868 468 3

British Library Cataloguing in Publication Data.
A catalogue record for this book is available from
the British Library.

Typeset in 9.5pt on 12pt Celeste.
Typesetting by Amberley Publishing.
Printed in the UK.

Introduction

St Austell, about two miles from the south coast, has developed from a 'poore village with nothing notable but the Paroch Church', according to John Leland, an early traveller in Cornwall between the years 1535 and 1543.

St Austell, Austol or Austle, a Celtic missionary saint, was a younger companion of St Mewan. They settled within a mile of each other, St Mewan still the neighbouring parish. Richard Carew in 1602 describes Trenans Austel indicating that the valley at Trenance was probably the first place St Austell chose to settle.

At Menacuddle, a little higher up the valley from Trenance, a hollow in the perpendicular rock face became known as St Austell Well and the baptistry building which still stands there has a permanent spring and stream of water flowing into a granite basin. It is likely that somewhere in this area a small cell with an enclosure was built possibly on the southern slopes, the site of the future town. In 1294, a record from the Tywardreath Priory notes 'Ecclesia de Sancto Austolo' indicating a small chantry chapel, later being replaced by a parish church.

The development of trade and business around the church is the history of many Cornish towns. In 1695, Celia Feinnes called St Austell 'a little market town' and about a hundred years later another historian, Richard Pococke, named it a 'little tinning town'. By the mid-1800s, W. G. Maton records that the place only has a church to recommend it but that 'there are large blowing houses at the western extremity' indicating growth and prosperity since the discovery of tin and copper deposits.

By 1833, St Austell was defined as a Coinage Town, indicating its importance, and from the time of Oliver Cromwell a market charter

had also been granted. This was soon followed by that of two annual fairs for the sale of livestock, coarse woollens and other manufactured goods. F. W. L. Stockdale, in 1824, records that the people of the town were 'industrious and thriving'.

The next development included the transition to the china clay trade in the early nineteenth century with the whole area around and to the north of the town producing some of the finest clay deposits in the world. The clay industry employed much of the local work force, the economic and social effects on St Austell being of great importance. The town developed and grew in all directions during the nineteenth and twentieth centuries and fine houses, avenues and buildings were added to the main streets. Trade in the town developed apace.

The villages around St Austell were thriving communities too and the importance of the town was obvious on market days, Saturdays and feast days when the population from outlying areas congregated in the streets. The shops thrived with trade, staying open until 9 or 9.30 p.m. on Saturdays. Canon Hammond, the vicar of St Austell in 1897, called it 'the most flourishing town in the county'.

There have been many changes in the town during the last five decades, with emphasis on large out-of-town stores cornering the shopping trade. We now have pedestrianisation in Fore Street and Vicarage Place, with the former area, Aylmer Square to South Street, undergoing massive redevelopment at this date.

<div style="text-align: right">

Valerie Jacob
September 2009

</div>

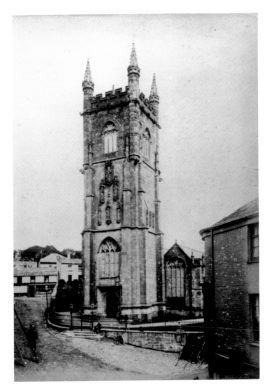

St Austell Parish Church
An early photograph taken in the 1880s from the end of Fore Street shows a fine view of the church tower. The splendour of the sculptured figures in the Pentewan stone quarried out of the local sea cliffs still grace the western face of the tower and outside walls of the church. Standing on an eminence at the crossroads, the parish church has withstood and witnessed many changes over 750 years.

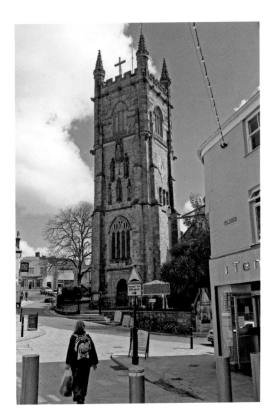

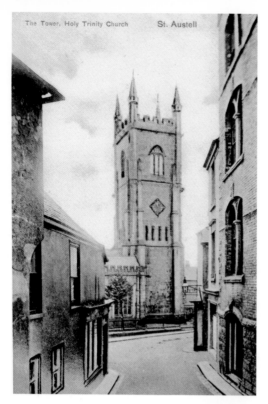

Holy Trinity Church

Dating from 1259, when Bishop
Bronescombe consecrated it, the parish
church of the Holy Trinity in St Austell
is the oldest building in the town and is
still used for its original purpose. Viewed
from the north side in the early 1900s,
alongside Tregonissey House, can be seen
the handsome clock face installed in 1883
on three sides of the tower. Note the Celtic
cross war memorial on the road side at
the base of the tower, erected in 1921 to
commemorate the men of the parish who
died in the First World War and, later, the
Second World War.

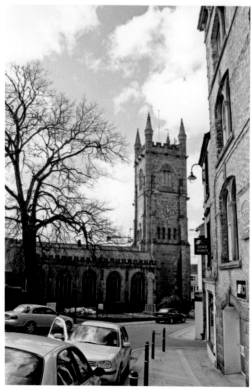

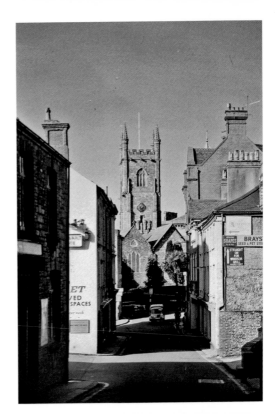

East Hill

Above is a view of the lower end of East Hill approach to the church during the 1960s when road improvements demolished many of the buildings on the left-hand side coming down the hill. It was once the main thoroughfare out of the town to the coastal ports and beyond into Devon.

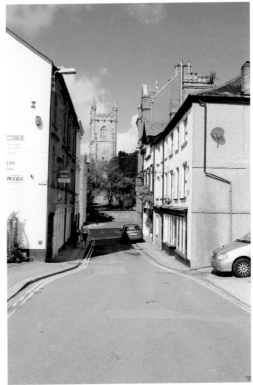

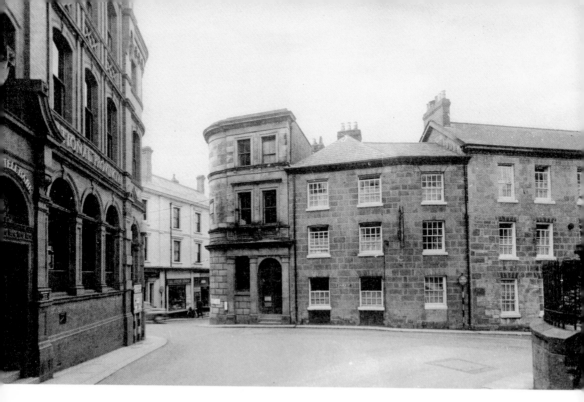

The Corn Exchange

At the lower end of East Hill on the corner of Hotel Road and Church Street was the Corn Exchange dated 1859; this fine granite building became the district Food Office during the Second World War. Demolished in 1960, for modern traffic purposes, it opened up today's view of lower East Hill.

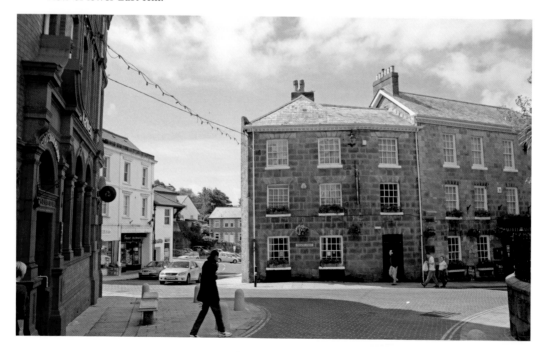

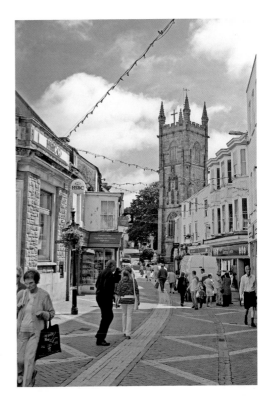

Fore Street

Halfway along Fore Street *c.* 1930 there is still two-way traffic and evidence of horse progress in the foreground. Today it is mostly a traffic-free haven, except for delivery vehicles. The varied architecture of the upper storeys still remains.

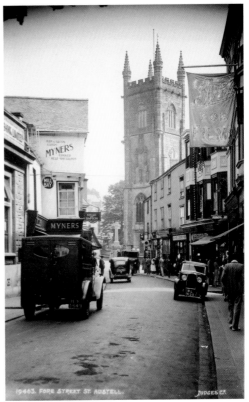

19463. FORE STREET ST AUSTELL. JUDGES C°

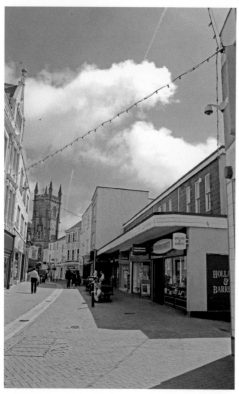

Fore Street

Further along Fore Street the edge of the
newly arrived F. W. Woolworth can be seen
on the right hand side, mid-1930s, with the
Blue Bird Café at the bottom of Chandos Place.
The 2009 photograph encapsulates the demise
of the Woolworth's era in St Austell and
throughout Britain.

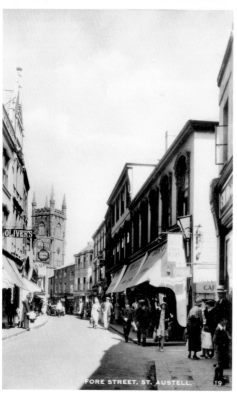

FORE STREET, ST. AUSTELL. 19

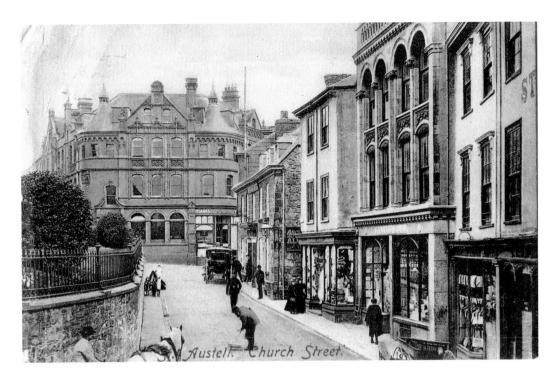

Church Street

1898 saw the newly built Victorian red brick bank building dominating Church Street; it is in stark contrast to the two-storey granite White Hart hotel alongside. Today's photograph shows the red bank virtually unaltered from the original Sylvanus Trevail plan, whilst the White Hart has had a third storey addition.

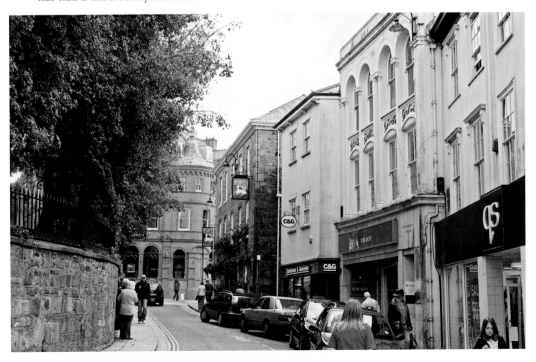

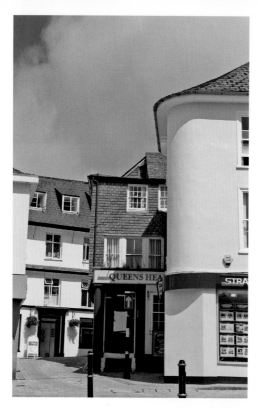

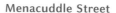

Menacuddle Street

Pictured is an old corner of St Austell, at the end of Fore Street and directly opposite the church entrance, which leads out of the town to the northern villages. It was once the site of the Mengu stone, an ancient marker of the division of the three Domesday manors of Trenance, Tewington and Treverbyn. In 1972, it was transferred to the churchyard at the base of the tower. The old Manor House, c. 1700, the exterior of which is still fairly undisturbed, has a curious slated cornice half way up and is now a dental practice.

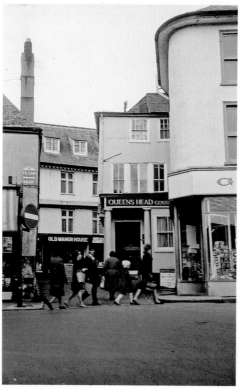

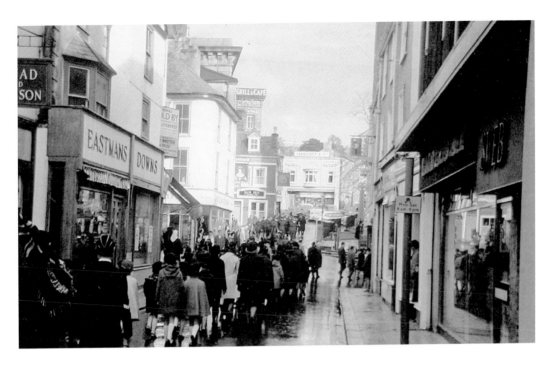

Armistice Parade, 1970

Above is pictured a very wet Sunday with the Armistice Parade heading along Fore Street towards the church. It included the Guides and Brownies in this section with a brass band assembled around the war memorial just visible in the old photograph. The modern view, with pavements removed, is hard to identify except for the premises on the corner of North Street, but Armistice parades are still held here.

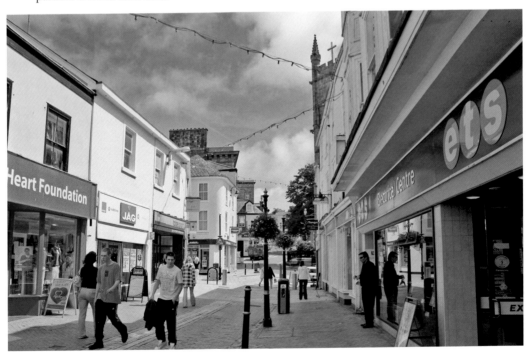

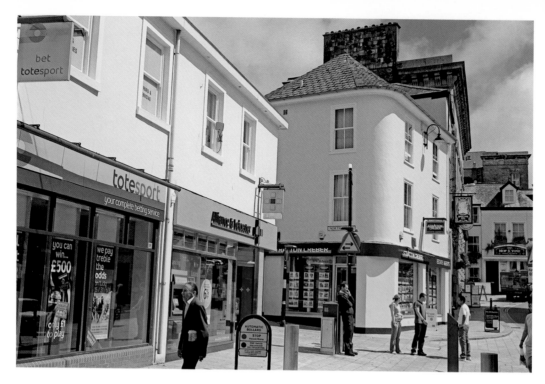

'Fool's Corner'

Demolition in 1972 at the corner of Menacuddle Street, nicknamed 'Fool's Corner' by local people in the twentieth century, marked a significant era of town improvement. Sites of the old stores of Pearks, Victor Wood, Eastmans and Downs, along with some property backing on to Biddicks Court, were totally cleared. Menacuddle Street was renamed North Street but its width remained unaltered.

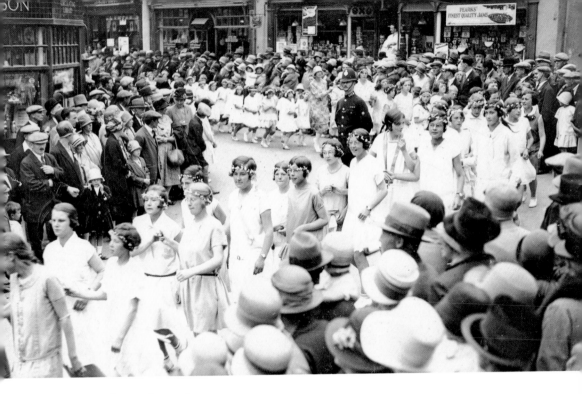

Feast Week Parade, 1928

Celebrations in July 1928 included many parades of church and chapels. The girls are mostly dressed all in white with flower head bands and their teachers are participating in the Flora Dance coming around the corner of Church Street. Spectators crowd the pavements on every side. In stark contrast the July 2009 photograph is a somewhat sad reflective sign of today.

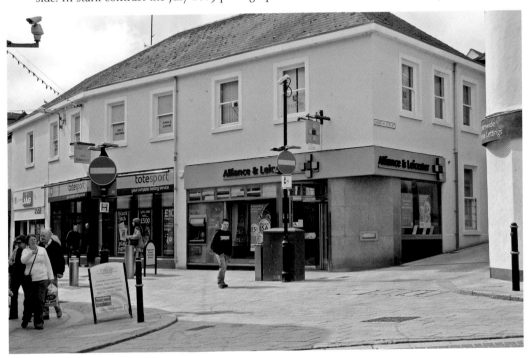

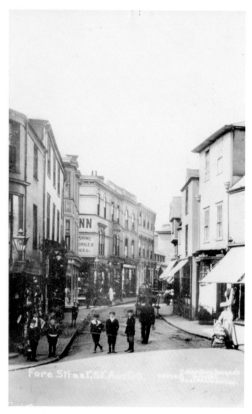

Fore Street
Looking westwards from the church at the
turn of the twentieth century, the boys
in Edwardian lace collars, caps and boots
span Fore Street. In today's view the blue
building on the left was a W. H. Smith store
from 1906 to 1981. The crane on the skyline
marks a new phase of building and the
redevelopment of St Austell.

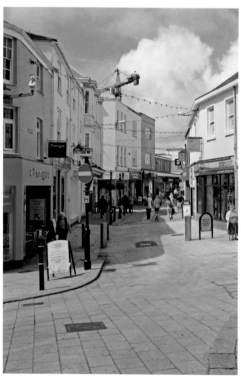

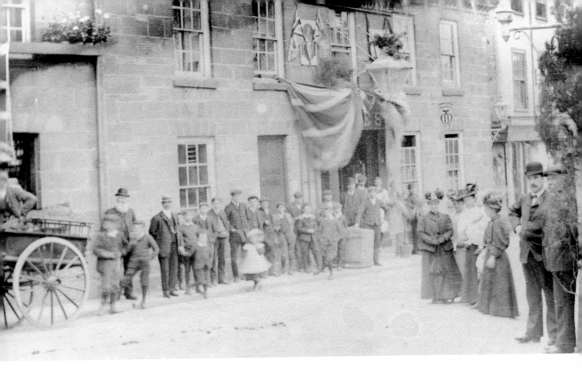

White Hart Hotel

The White Hart Hotel premises, built as a private residence in 1769 for Charles Rashleigh, is seen here in 1909 decorated for the royal visit of the Prince and Princess of Wales. Formerly a two-storey building built for the remarkable man who developed Charlestown and its harbour, it became bank premises and a solicitors' office. The third storey in the modern view was erected in 1925 by Walter Hicks and Company Ltd and the business continues under the St Austell Brewery name today.

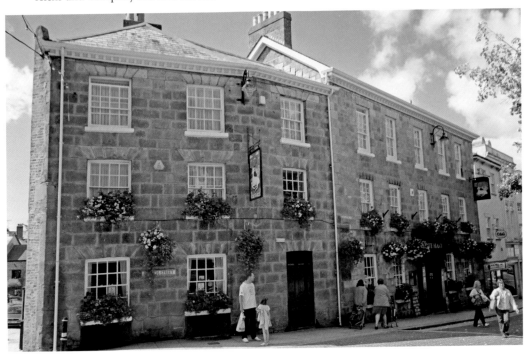

White Hart Extension

Both images on this page show the extension of a new wing built on to the back of the White Hart facing South Street. In 1986, further demolition opposite opened up the view to the re-routed East Hill and thus made this area much quieter.

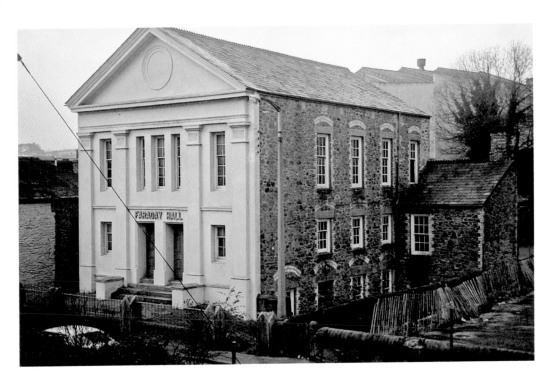

South Street

The approach to St Austell via South Street was lined with some fine buildings, terraces and private residences built from the 1850s onwards. Faraday Hall had formerly been erected as a Primitive Methodist chapel in 1876. During redevelopment in the 1960s this building was demolished along with Wisteria Cottage, a pretty Georgian residence alongside. The crane on the skyline marks a phase in that development of St Austell.

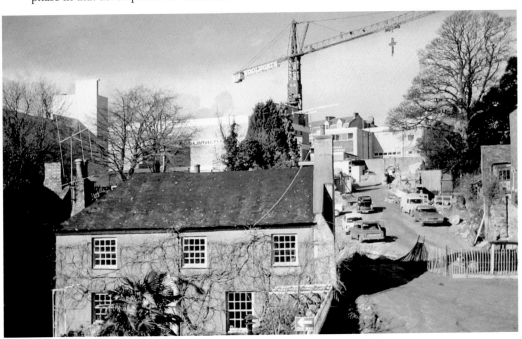

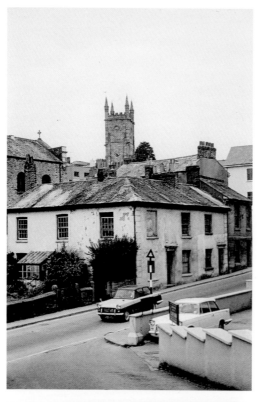

South Street
The views from half way down South Street show how much the face of the old town was altered. Here note the residential areas, including the Congregational chapel being razed to the ground for road widening and modern office premises.

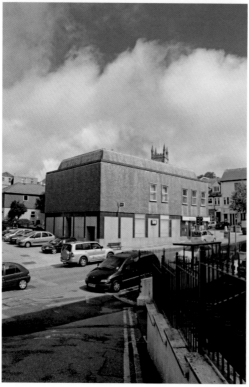

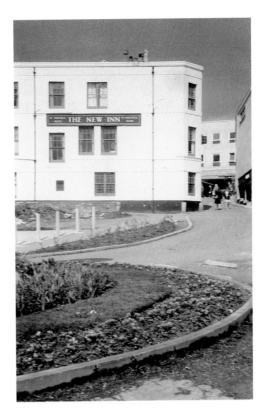

The New Inn

The New Inn, Chandos Place, led off Fore Street and is shown here shortly before its demolition in 1963/4 to make way for a Woolworth's extension. The garden of the Odeon Cinema is in the foreground. The insert, superimposed over the view today shows a rare 1916 glimpse of F. Warmington's tobacconist shop at the Fore Street end leading down into Chandos Place in the era before F. W. Woolworth was built.

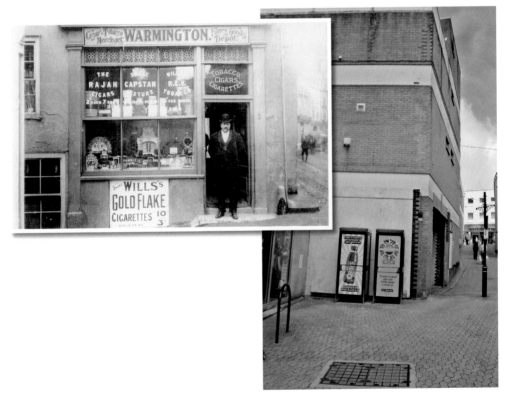

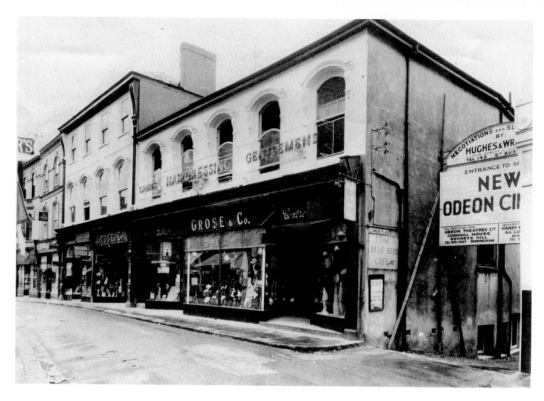

Chandos Place

Pictured is the entrance to Chandos Place from Fore Street in 1935 when a site for the new Odeon Cinema was purchased. It opened on 11 July 1936 with a spacious car park for over 200 cars alongside. The inset includes the cinema as shown in the souvenir programme of the grand opening.

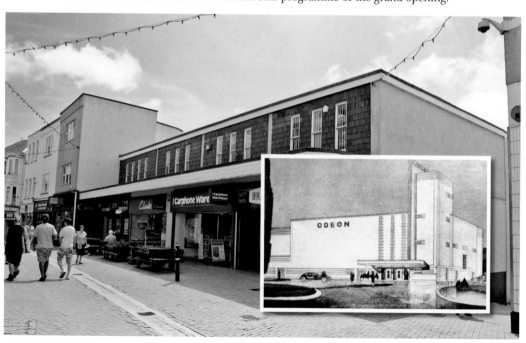

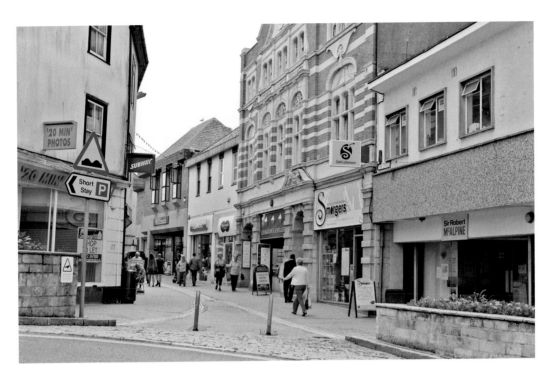

Fore Street — West End

At the western end of Fore Street, where an old smithy had once stood, a Liberal Club for the town, designed by Silvanus Trevail, was built in 1890. There were around 400 members when it opened, underlying the political sympathy of the area. Although no longer the Liberal Club, the ornate front of the red and white brick and granite arched entrances are still evident today alongside much altered shop frontages.

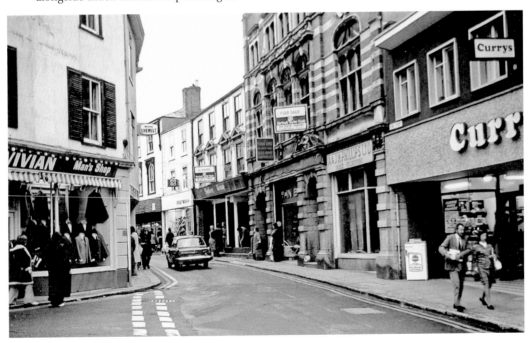

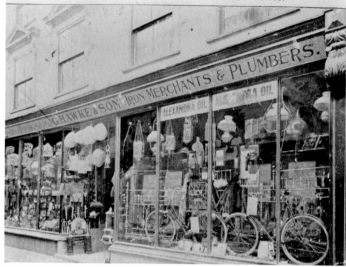

From GEO. HAWKE & SON, St. Austell.

ALSO AT FOWEY.

Telegrams:—
" Hawke, Ironmonger, St. Austell."

GENERAL

Ironmongers

AND

Iron Merchants

Telephones:—
St. Austell, No. 6.
Fowey, No. 13.

George Hawke & Son

George Hawke & Son's premises, 37 Fore Street, in 1910, alongside the Liberal Club premises. With two large display windows it was like an Aladdin's cave with merchandise jammed into all available space. This ranged from ladies' and gents' bicycles, iron bedsteads and paraffin lamps of every design to everyday crockery and best china. The later 1976 view shows that Sydney Grose has vacated the premises. Today, the plate glass shop fronts of the usual High Street stores predominate.

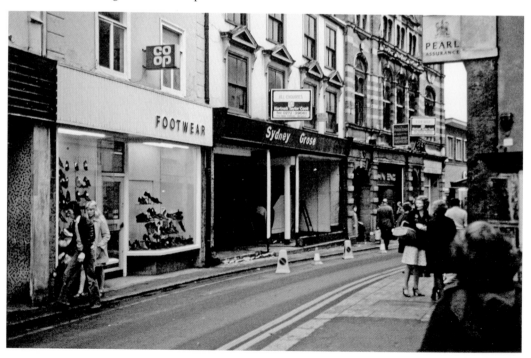

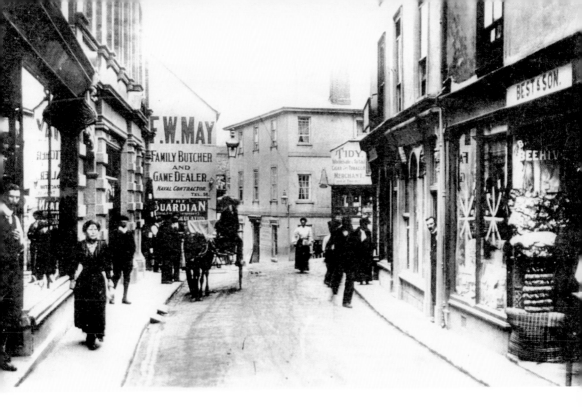

West End — Tidy's Corner

The corner of Fore Street, Bodmin Road and Truro road was long known as 'Tidy's Corner'. This little corner shop was a cigar and tobacco merchant's premises called Tidy. In the earlier view the spacious Globe Hotel features at the top end of Truro Road, with Warne's the printers occupying the ground floor. The building is still clearly seen today.

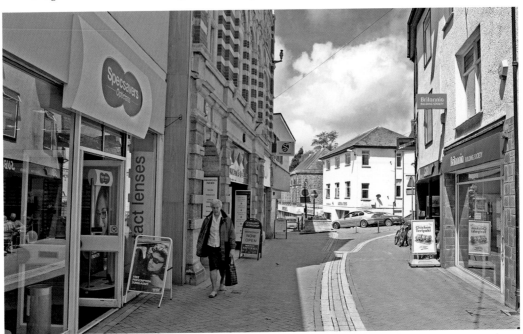

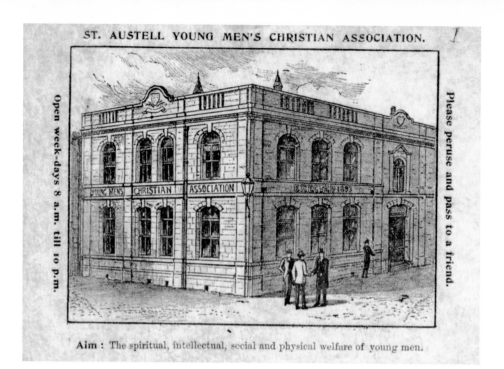

ST. AUSTELL YOUNG MEN'S CHRISTIAN ASSOCIATION.

Open week-days 8 a.m. till 10 p.m.

Please peruse and pass to a friend.

Aim : The spiritual, intellectual, social and physical welfare of young men.

Victoria Square

This building, erected in 1893 on the site of the Ring of Bells public house, was the first YMCA building in Cornwall. It had a gymnasium and reading room catering for the education and welfare of the young men of St Austell. The ground floor has been vastly altered over the years but the pleasant stonework, the Cornwall coat of arms and the 1893 date stone can still be seen on the ledge below the parapet.

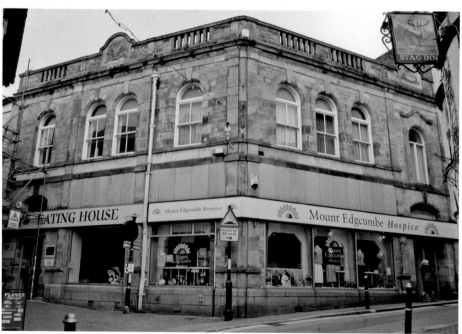

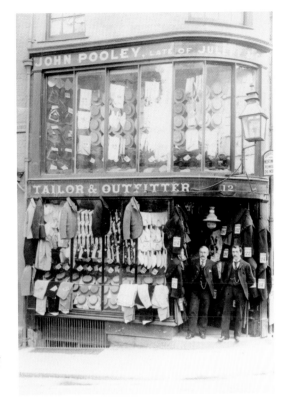

Shop Frontage, 1885

The old view tracing one of St Austell's earliest shop fronts spanned the corner position of Church Street and Fore Street. Coats and trousers were hung outside the shop windows, whilst smaller items and boaters took over inside. A gas lamp is hung over the entrance. Only the angle of the wall and the Church Street sign offer a clue to its whereabouts in 2009.

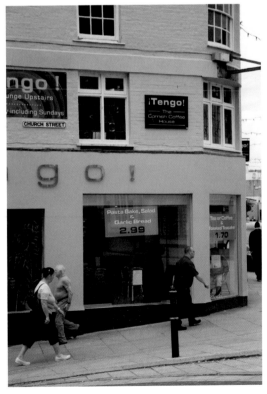

Duke Street

The large Congregational chapel in Duke Street was built in 1850, on the site of an even earlier chapel. In the 1880s additions and alterations were made by Sylvanus Trevail and, with a Sunday school underneath, was a Grade II listed building. The chapel closed in the 1970s and was later demolished. The site formed the British Legion Garden of Remembrance and Club premises with the new town centre behind. Forty years on another set of cranes towers over another rebuild in that area.

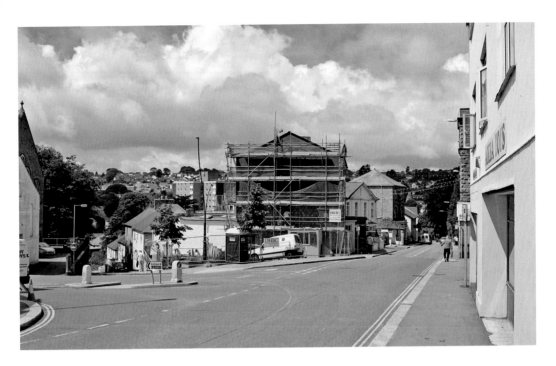

West Hill and Truro Road

The angled building on the corner of Truro Road and West Hill, once known as Tower House, was always used as a shoe shop and was formerly Parkers, the West End store. In March 1923, it became Goodenoughs where this family ran the business here for over forty years before relocating to the new town centre in 1965 to make way for road improvements. The new road on the left was named Trinity Street, the shop site now difficult to visualise, with only the houses in West Hill offering a clue.

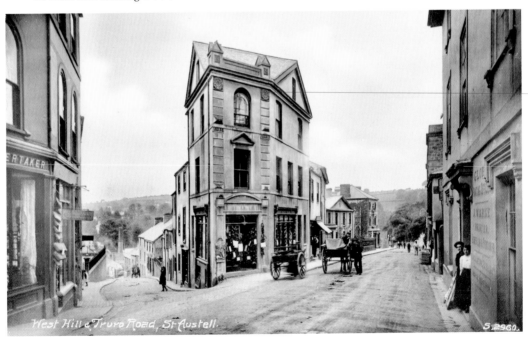

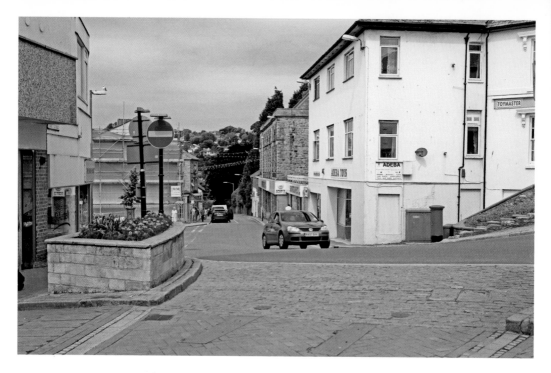

Truro Road, 1920

A closer look at the junction of Truro Road into Fore Street. The Globe Hotel and the imposing building of the Public Rooms on the right, further down on both views. Old shop frontages on the left hide the approach to the West Hill exit to the town. Open fields in the distance are now occupied by houses at Trevarrick.

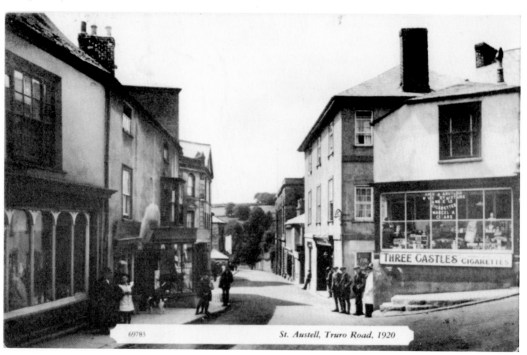

69783 *St. Austell, Truro Road, 1920*

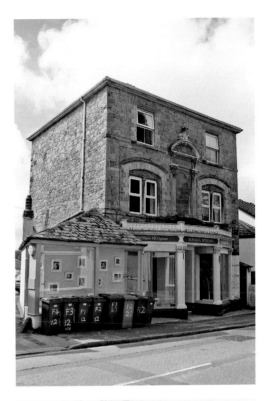

Monumental Masons

Doney, Son, Watts and Trevail premises in Truro Road was a fine ornate building and showroom of the business known as statuary masons. Note the fine statue on the plinth outside on the pavement and glass-domed alabaster-carved grave wreaths in the shop display. The building structure remains intact today, the alcove above the main entrance still clearly definable, minus the figure.

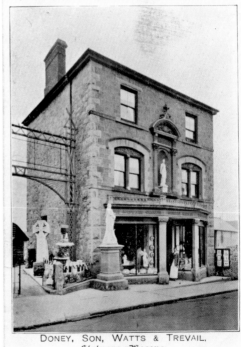

BRANCH ESTABLISHMENTS—Pydar St., & 12, Francis St., Truro.
Station Road, Falmouth.

DONEY, SON, WATTS & TREVAIL,
Statuary Masons,
WEST END, ST. AUSTELL, CORNWALL.

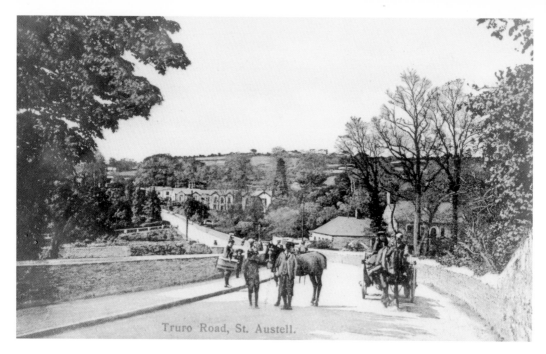

Truro Road, St. Austell.

Truro Road

Truro Road built in 1834. This gently wooded approach to St Austell stressed the newly acquired wealth brought to the town by the china clay industry, and substantial new dwellings were built by the clay magnates. A new bridge was constructed over the St Austell River. Some of the fine specimens of the trees remain in the grounds of the Trevarrick residences.

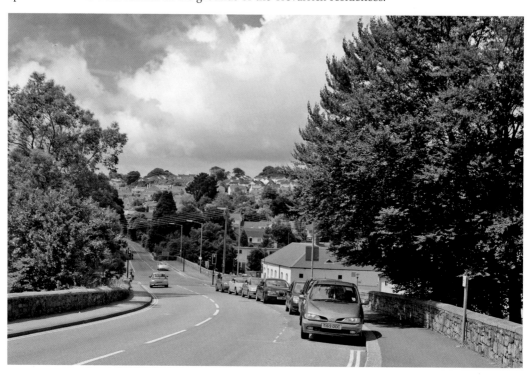

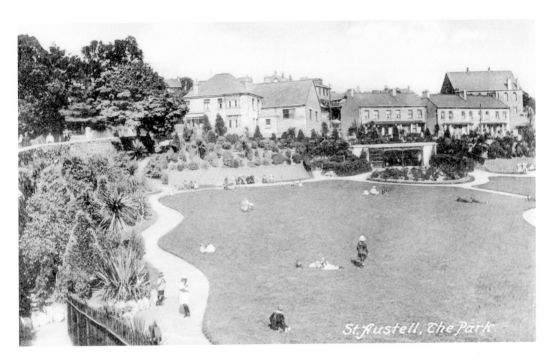

The Park

In 1920, the park was laid out with paths, shrubberies and flowered beds to complement the approach to the town and to provide recreation for the town's people. Local dignitaries led by Mr Harry Hodge commemorated the opening ceremony in front of the shelter beyond the circular flowerbed. These two features are still present, along with a few of the original trees.

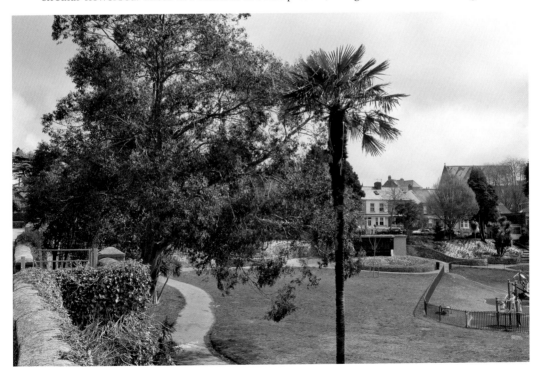

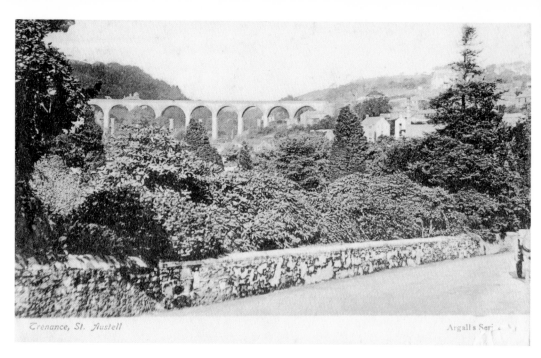

Trenance, St. Austell Argall's Ser...

Trenance

Standing in Truro Road opposite the park it is still possible to see the granite viaduct, built to take the trains onward from St Austell through Cornwall, spanning the Trenance Valley.

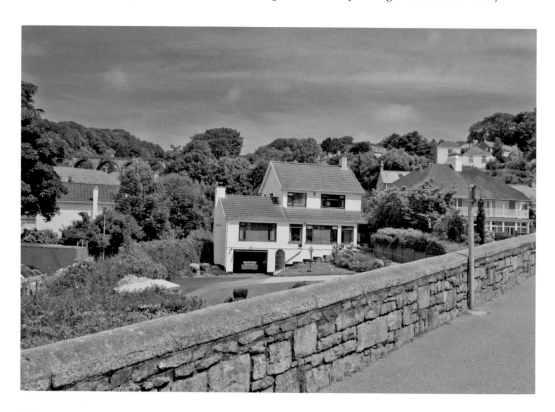

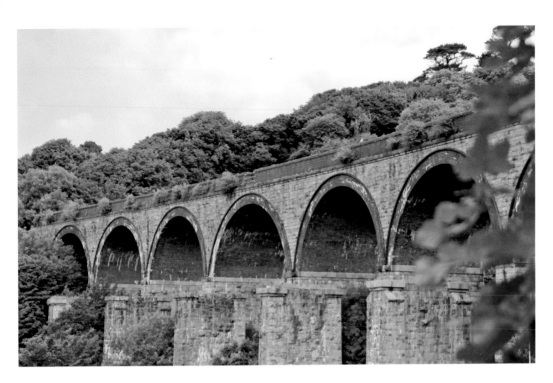

The Railway

The railway came through St Austell in 1859 continuing to Truro and the West. This old view of the first trestle bridge, carrying the single track, which was erected by Isambard Kingdom Brunel, shows the inverted wooden trestles fixed to stone piers. The remains of these pillars are still visible today alongside the new granite viaduct for the double track.

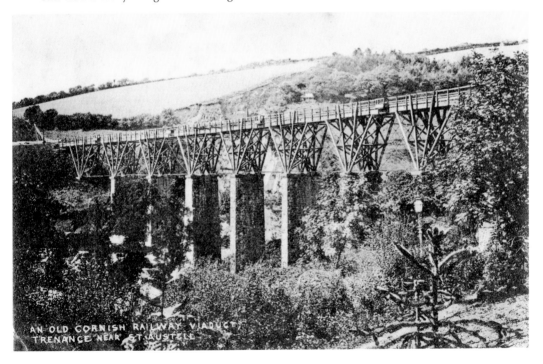

AN OLD CORNISH RAILWAY VIADUCT, TRENANCE NEAR ST AUSTELL

St Austell Viaduct

In 1898 a replacement viaduct was built of local granite to carry a double track. Ten brick arches spanned the valley overlooking Trenance Mill and the industrial area around. On the left at the beginning of the viaduct nearest the town the toll house, built in 1840, is just visible on the Bodmin Road.

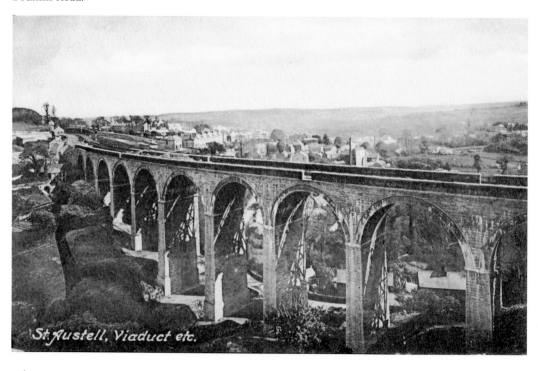

St Austell, Viaduct etc.

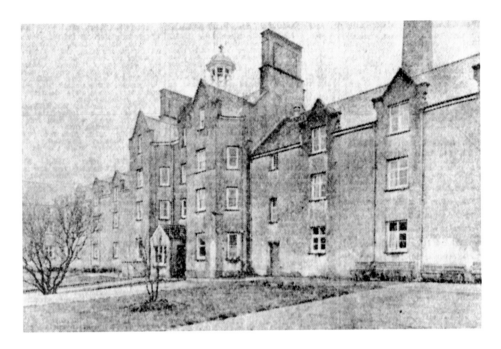

Sedgemoor Priory

This old cutting shows the workhouse built in 1839 for the parish. It replaced a former one at the bottom of West Hill on a site known as Workhouse Lane. The new building was erected in part of the old Sedgemoor Priory grounds and could take 300 inmates. In 1954 it was a home for old and infirm people. Today the new offices, known as Sedgemoor Centre, are managed by Cornwall Council Adult Care Support, so, interestingly, the site is still caring for the community.

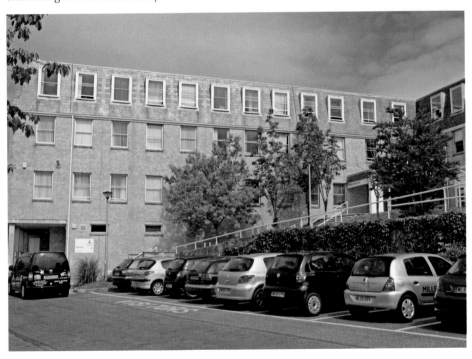

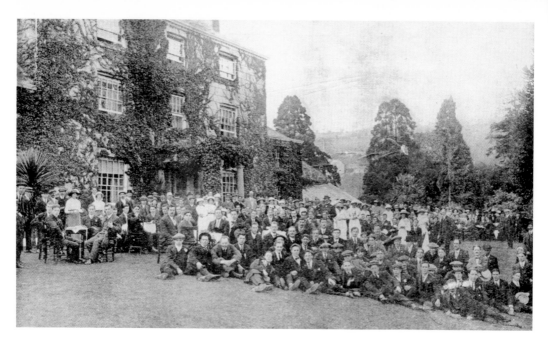

Trevarrick Hall

Trevarrick, a former estate in the western area of Trenance, was owned by Henry Hodge Esq. in 1914. The old view shows recruits for the Cornwall Light Infantry being entertained on the lawns in the front of the house. The fine ashlar stonework and porch is still in evidence today, even more accentuated by the removal of the ivy or Virginia creeper of yesteryear.

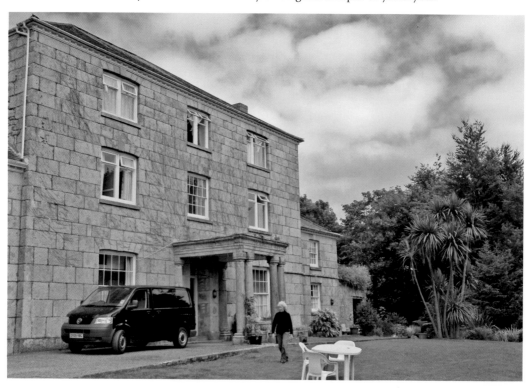

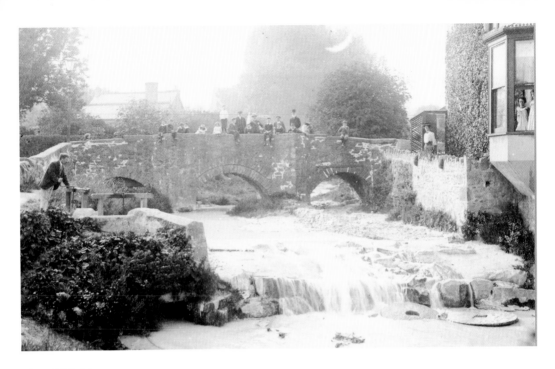

The Old Bridge

Taken in 1906 this view shows the old granite bridge spanning the St Austell River at the bottom of West Hill. It carried the original turnpike road to the west. Dating from the fifteenth century the roadway is only eight feet wide (2.4 metres). Sluice gates on the left could control the flow of water for the wheel at Pondhu Mill. Although the growth of plants hide the river, the arches are clearly visible under which a clear stream now flows.

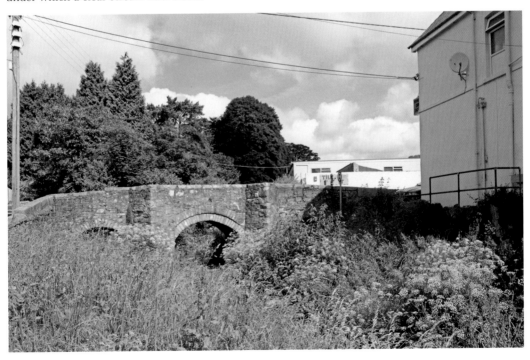

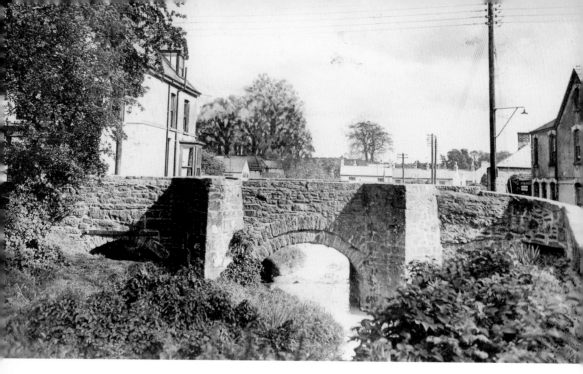

West Bridge

Pictured above is the bridge over the St Austell River in the 1950s still containing white deposits of china clay on its journey to the sea at Pentewan. The newer view of the bridge, which has a clear stream flowing beneath it, is unaltered except for its modern surroundings. The bridge is now closed except for pedestrian traffic.

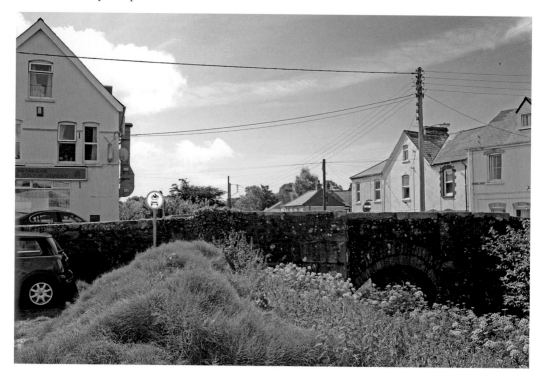

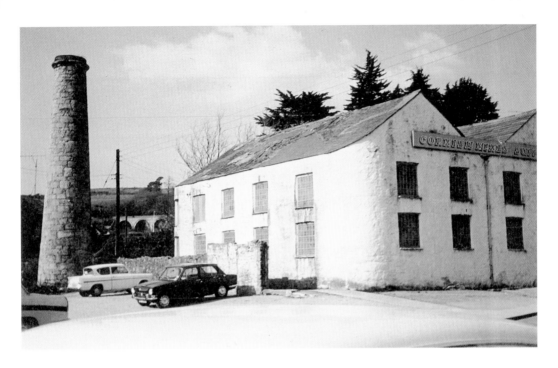

The Foundry

Still in the same area, the foundry premises of the early nineteenth century played a major role when the local industry, before china clay, was tin mining. The chimney still towered over the site in 1960 when the Cornish Mines Supplies Co. Ltd continued to trace a semblance of the site origin. Today modern retail services have swallowed the site, and only the trees bear witness fifty years on.

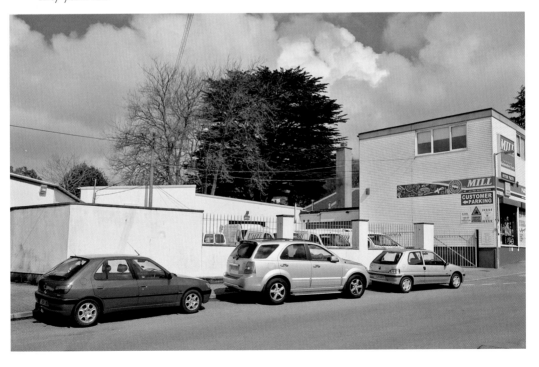

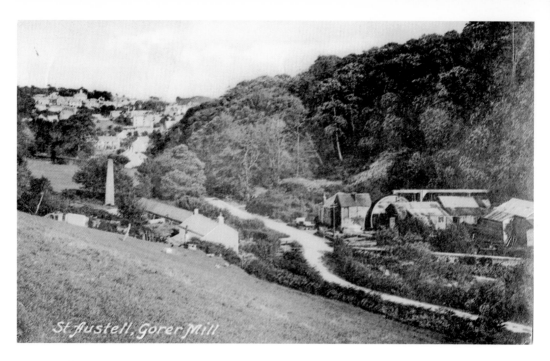

St Austell, Gover Mill

Gover Mill

Still an industrial scene in 1920, Gover mill in the Trenance valley shows a rural aspect, with the town beyond. The huge overshot water wheel, fed by a long wooden launder, and a cluster of mill houses on the banks of the river all contribute to the industrial past. St Austell, seen in the background, has finally encroached upon this site with new residential building.

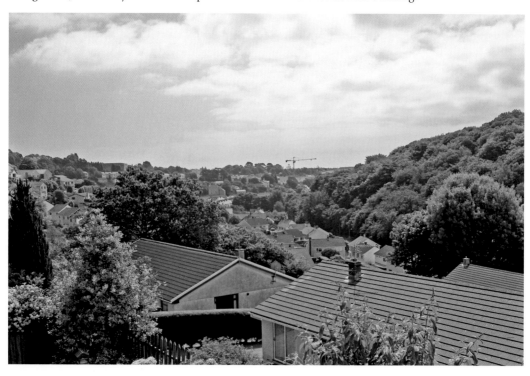

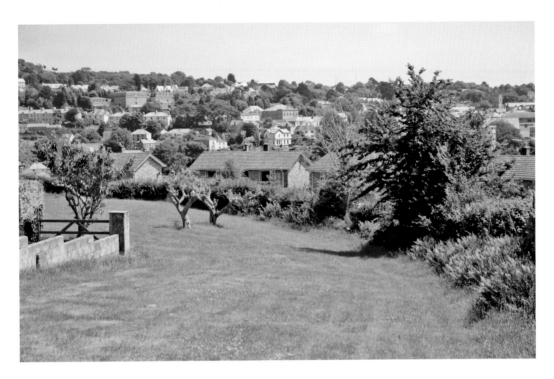

Town — Overview

A sweeping view of the town from the Old Cottage Hospital Hill leading towards Trewoon. Modern housing development in the last forty years has almost obliterated the older buildings and the railway line embankment in view behind the vast workhouse site is no longer discernible.

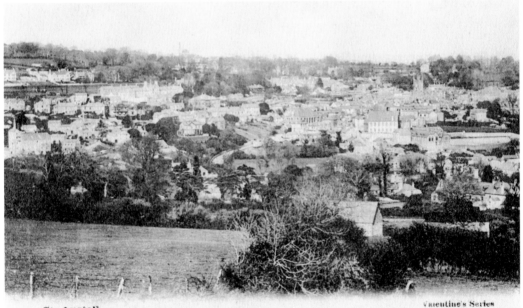

St. Austell. Valentine's Series

43

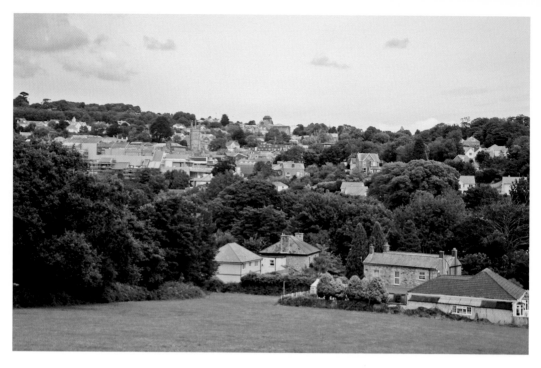

St Austell — Overview

A second sweeping view from the London Apprentice side of the valley from Trewhiddle farm fields. The St Austell brewery building and flagpole can just be identified on the skyline of both images, as well as the church tower. Mature trees have obscured most of the later view.

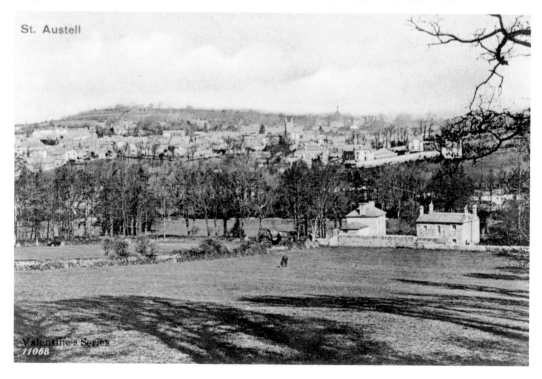

St. Austell

Valentine's Series
11068

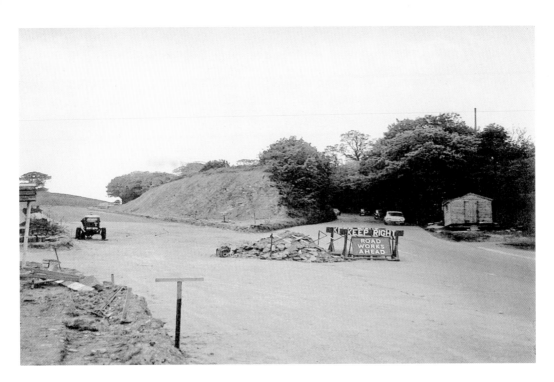

Road Improvements

In 1965 this road development from St Austell to Truro altered the western road from the town through the St Mewan 'dip'. Known locally as Colizza Hill from earlier times the amazingly unsophisticated 'Keep Right' warning on the road sign at the junction beggars belief today!

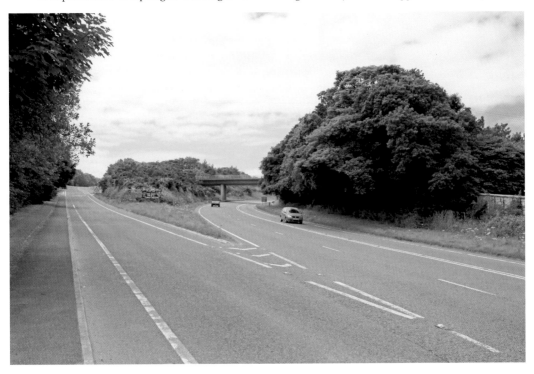

Angle House

In October 1986 another East Hill development scheme saw the demise of the old Services Club, once a Methodist chapel. The area was cleared further. Only Angle House, a Georgian building of Pentewan stone, survives the scene unmolested.

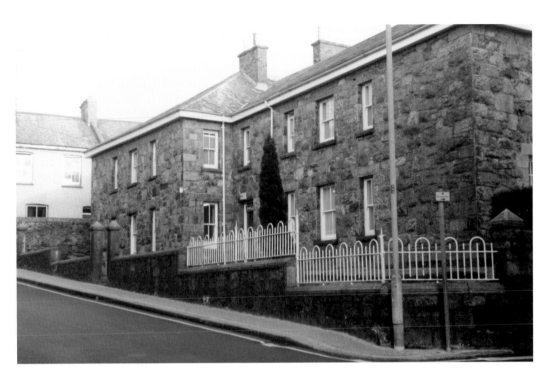

The Old Police Station

St Austell Police Station in High Cross Street was built in 1866. It was a stone structure with accommodation and police cells replacing the two cells formerly used under the town hall. From 2003, the site is still empty, and a newly erected police station opened in 1989 on Palace Road.

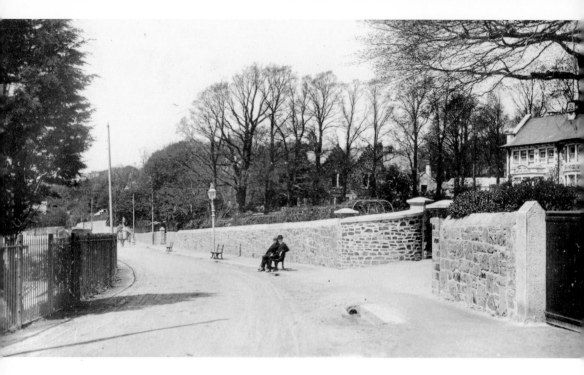

Palace Road

Palace Road was newly built and developed after the advent of the Great Western Railway from Plymouth into Cornwall in 1859. Several new residences were built by the clay magnates or prosperous business people in the town set back off the road within their own spacious grounds. The walls remain today, but the fine gas lamps and seats have disappeared.

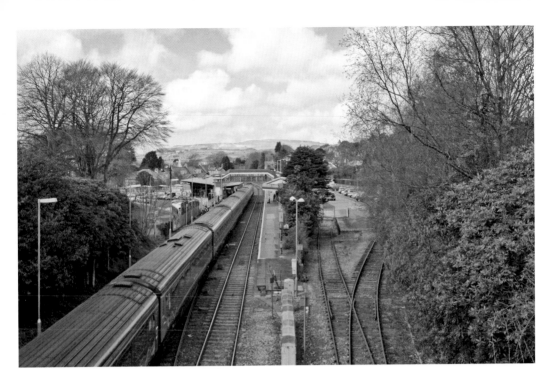

Railway Station

St Austell Station *c.* 1912 with the upward line train, the engine getting up steam to depart and the water tower nearby. On the left by the station buildings was a large goods siding and on the right other goods wagons have been shunted back into more sidings below Palace Road. The main goods' depot was transferred to yards at Polkyth in 1931. Cars now park in that area to the right. Note the GWR dated footbridge evident in both scenes.

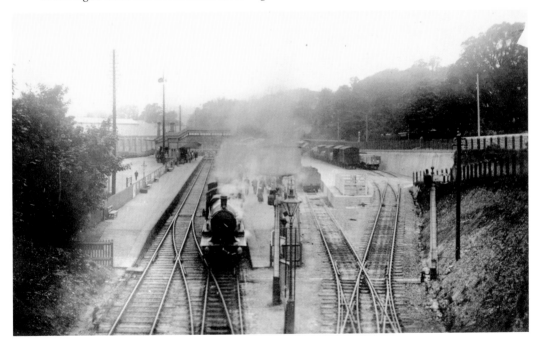

Station Premises

A few goods' trains still used the sidings below Palace Road in the 1950s but the Western National bus company has also entered the scene, providing services to all the outlying district and villages. Cattle pens are still *in situ* on the siding to the left of bus no. 68. Today, access to the yard is completely overgrown.

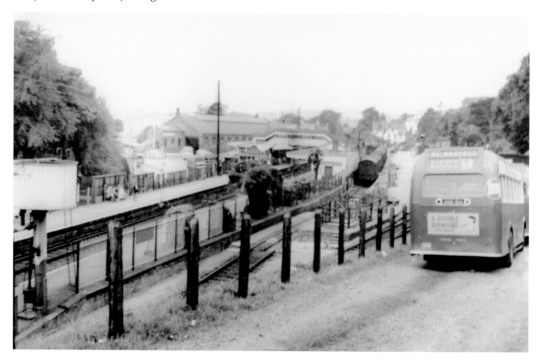

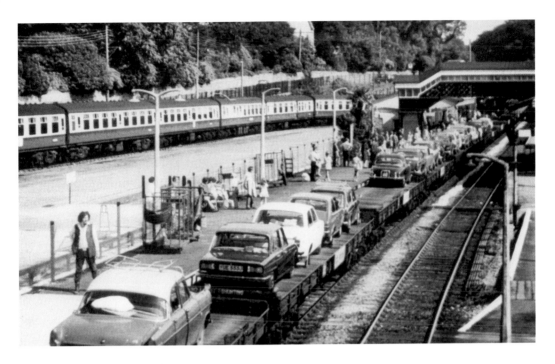

Motorail at St Austell

This mode of rail travel developed as a stress free way to reach the West Country and was very popular for several years in the 1960s and early 1970s. The Motorail passenger train pulled into the old goods' siding under Palace Road and all passengers alighted and crossed over on to the station platform to await the unloading of their vehicles from the special flat bed trailers. This era of British Rail history is sharply contrasted by the platform scene in July 2009 where only a two-carriage train is evident.

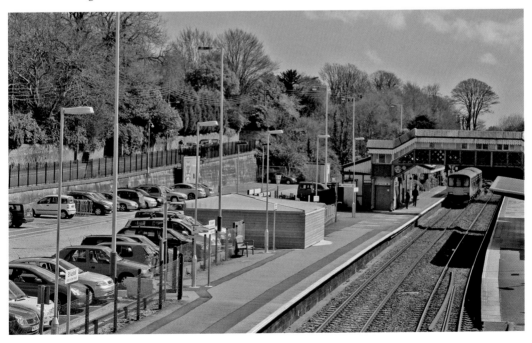

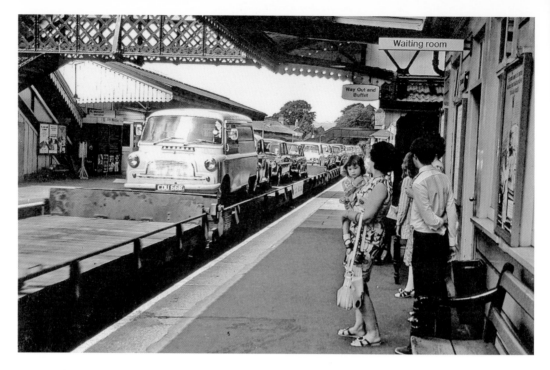

Motorail — Platform View

The Motorail line of cars still used St Austell station in 1972. Local people often came to wait and watch for the Motorail train. On the platform in 1972 was Mrs Roselle Lutey holding Anna her daughter. This photograph was taken by Mr Jack Rowe of St Austell, Roselle's brother-in-law. The iron footbridge crossing the line still exhibits the G. W. R. sign and 1882 date seen top left in the colour photograph and inset.

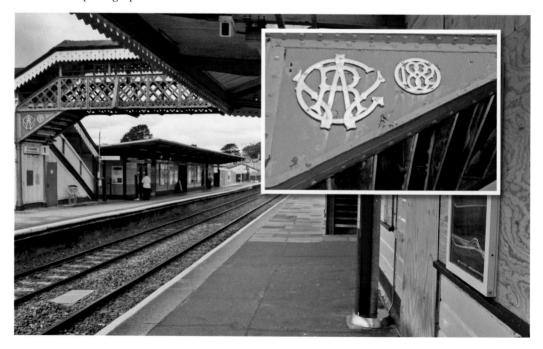

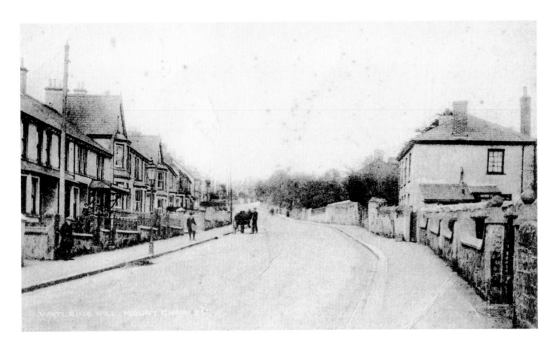

Watering Hill

An approach to St Austell from the easterly direction *c.* 1910. The old name of Watering Hill evolved from the days of horse-drawn traffic when horses would stop for watering from the open river at the bottom of the hill. It was renamed Alexandra Road sometime after the accession of Edward VII and Queen Alexandra, who was beloved by her subjects. The shop canopy on the left was a small grocery store for many years for Messrs Turner, Higman and Jacob and is still visible today as a much-enlarged electrical home appliance store.

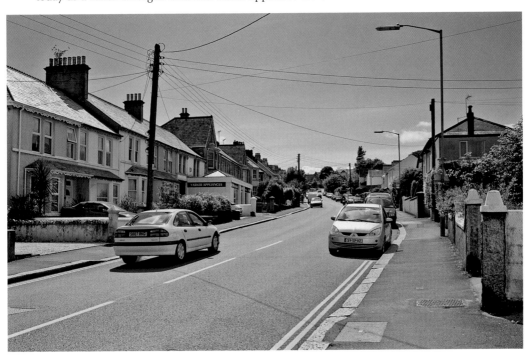

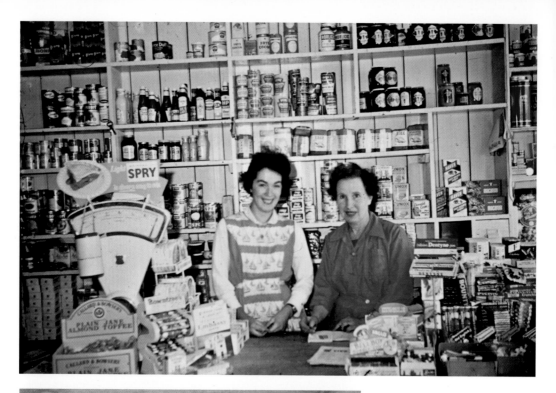

Jacob's Stores

An exterior view of the same grocery premises in 1974 — still a grocery and provision store belonging to P. and M. Jacob, with boxes of fruit and vegetables displayed outside. Pictured in colour is Phyllis Jacob with her daughter Diana behind the counter in 1961. The shelves make fascinating scanning.

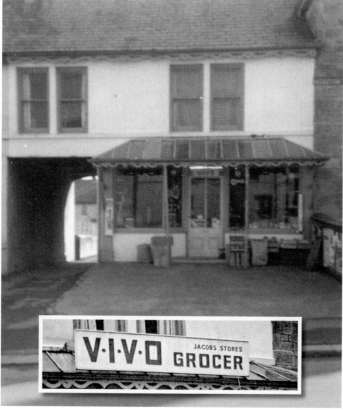

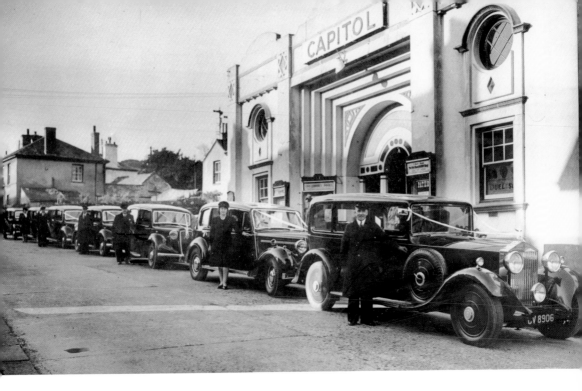

The Capitol Cinema

At the bottom of Alexandra Road the second cinema was built for St Austell. It had a ballroom and restaurant as well as an auditorium for the screening of the films. The line of wedding cars in 1948 were waiting for the guests and bridal party after the reception in the ballroom upstairs. The Rolls Royce with the owner alongside headed the line. Today the modern building houses Capitol bingo sessions.

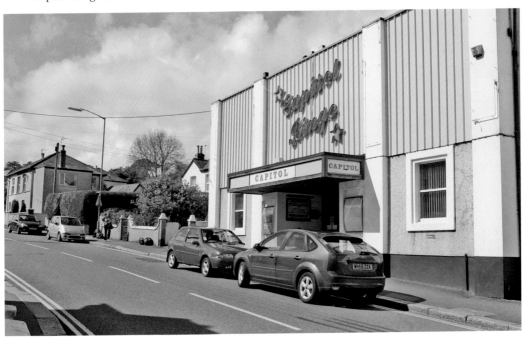

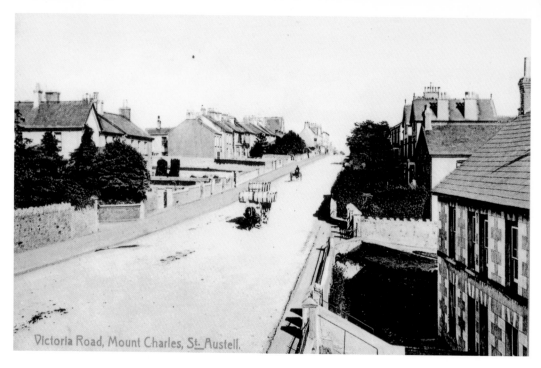

Victoria Road, Mount Charles, St. Austell.

Victoria Road
Victoria Road led into Mount Charles, once the next village settlement after St Austell. The view shows a very empty thoroughfare at the turn of the twentieth century. The horse-drawn vehicle loaded with wooden clay casks can travel safely in the middle of the road. Contrast today's view.

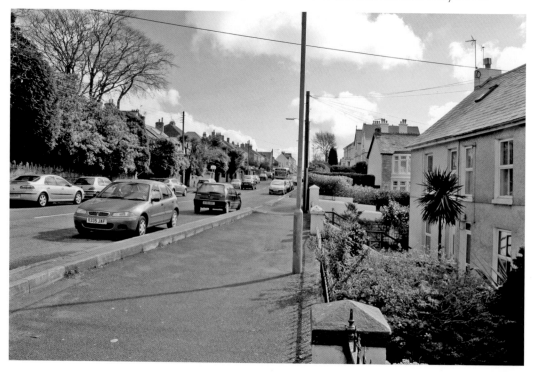

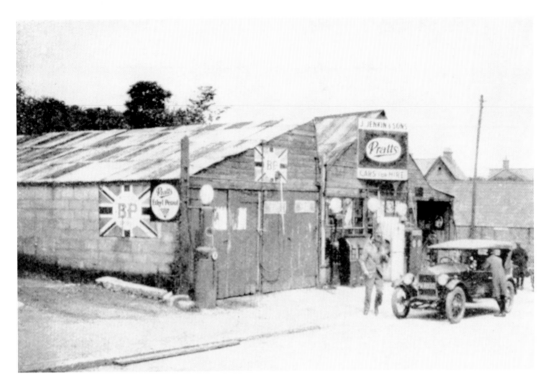

Jenkin's Garage

This garage site was let to J. Jenkin on a twenty-one year lease from 1910. At the base of Alexandra Road, it was ideally situated on the main traffic route in and out of the town. It was sold by public auction in 1922, but no further building evolved and today it is a car park for Capitol bingo and other businesses nearby.

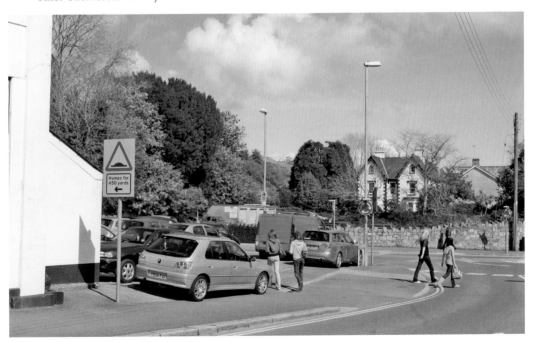

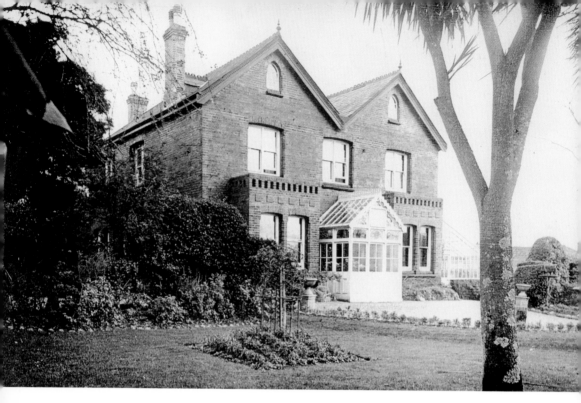

Moorleigh

This large residence called Moorleigh, on Victoria Road, was built by Mr Thomas Treleaven
c. 1888. He was a prominent businessman of the town and had corn merchant premises in East Hill.
Surrounding grounds hid the house from general view and the extensive gardens, green houses,
coach house and yard stretched into Wesley Place at the rear. The house was sold in the 1960s and
an estate of town houses was built on the site. The only clue to its former history is the retained
name Morleigh Close on the left of the roadside wall.

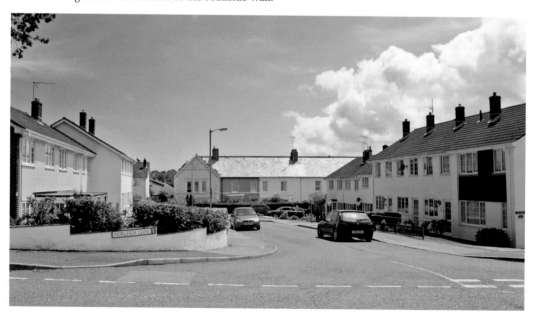

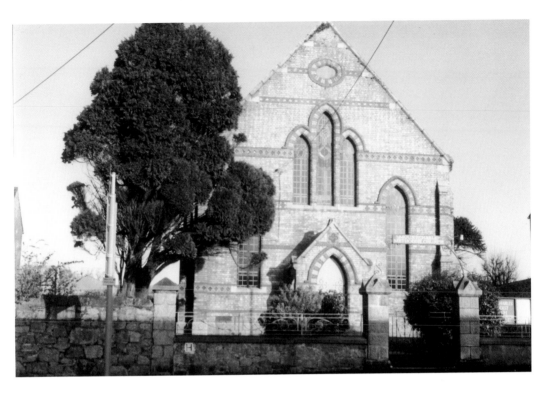

Mount Charles Chapel

Mount Charles Wesleyan Chapel was built in 1873 and was designed by the Cornish architect Sylvanus Trevail. It provided witness for many generations of ardent Wesley adherents. The new building in 1995 used some of the Trevail brickwork in its construction.

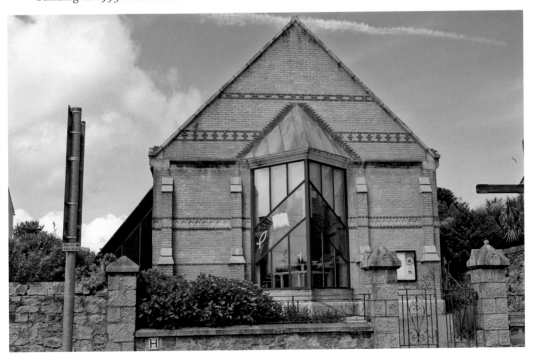

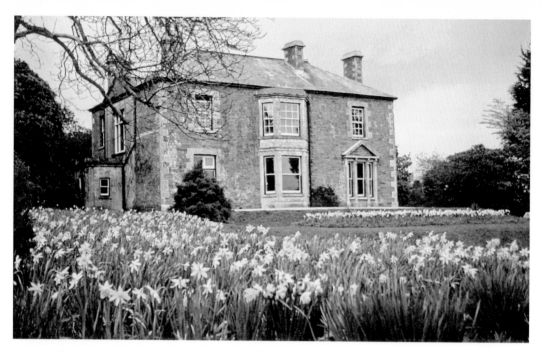

Polkyth House

This fine house was built on the outskirts of the town in Carlyon Road and was the substantial home of J. S. Lovering. Only the name in the leisure centre complex remains after 1974 plus a few fine trees which had been planted in the grounds of Polkyth by the Lovering owners.

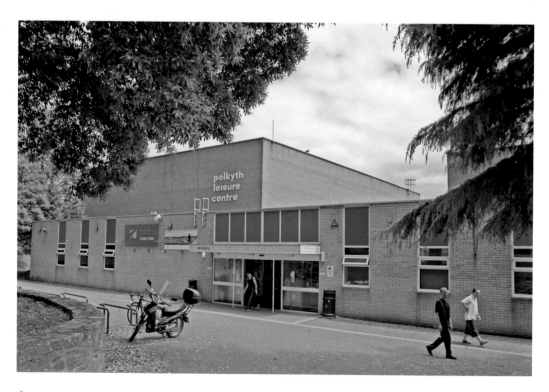

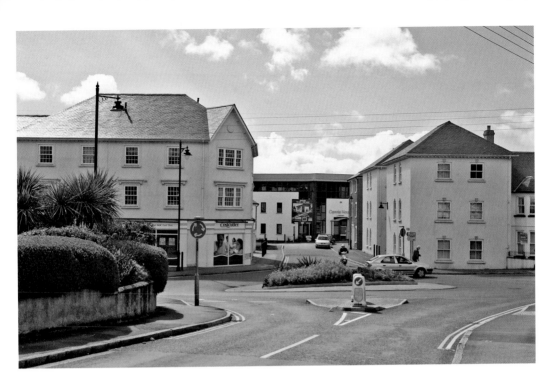

Goods' Yard — Polkyth

The goods' yard of the Great Western Railway was moved to this site at Polkyth on Carlyon Road in 1931. After it became redundant, as more and more haulage was taken over by road traffic, it remained for many years a silent witness to the one time thriving rail link. In 2002, the whole site was purchased by a developer. Now known as 'The Village' it has houses, shops, apartments and office accommodation.

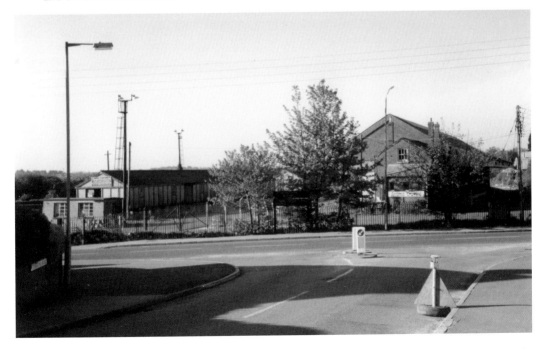

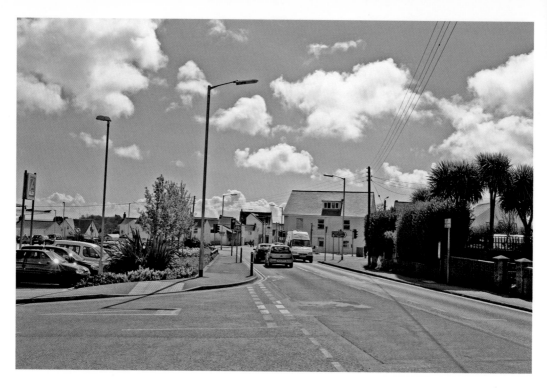

Treleaven's Cross

Carlyon Road leads on to the crossroads at Treleaven's cross, where Slades and Clifden Roads and Sandy Hill all meet. The barns and farm outbuildings of Mr Jenkins and Cundy's garage on the left were a landmark feature in the area for many years. Today only the large building in the centre is identifiable. Formerly a well-stocked shop owned by Mr Bohemia — a newsagent, clothes store and fancy goods outlet — the corner took the name Bohemia's from its owner. A new supermarket is on the garage site.

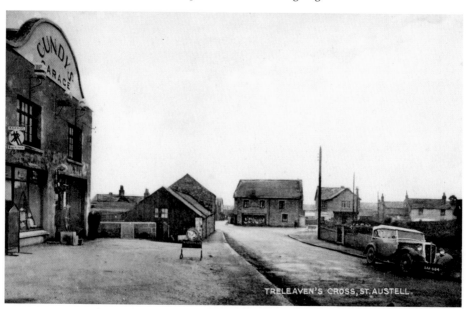

TRELEAVEN'S CROSS, ST. AUSTELL

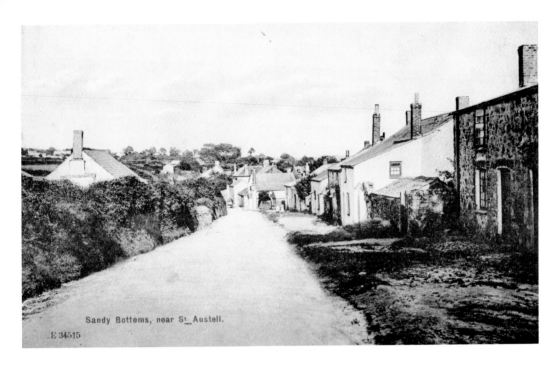

Sandy Bottoms, near St Austell.

E 34515

Sandy Hill

The view down Sandy Hill from Treleaven's Cross shows rough hedges and no development leading past the farm on the left. It is traffic free and seems a quiet backwater leading on to the village of Bethel. Today, all the hedges have gone and a large primary school has been built on the left-hand side.

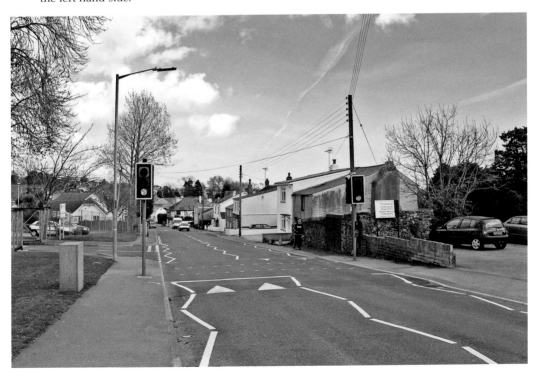

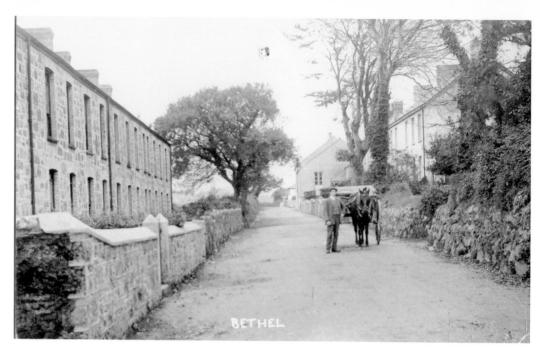

Bethel

Bethel Village, about one and a half miles from St Austell, is seen in the early view as a straddle of houses along a country lane in 1910, traffic being restricted to horses and pedestrians. The large building at the end of the row of houses on the right is the Methodist chapel, which was built in the early 1800s and is still thriving today.

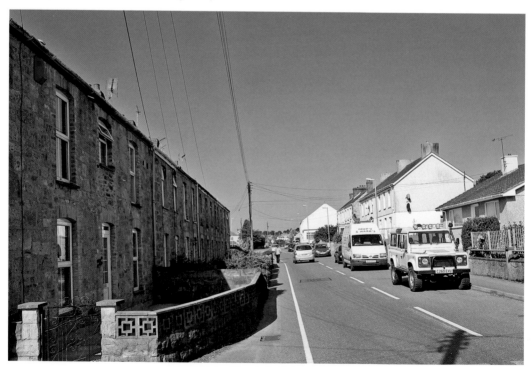

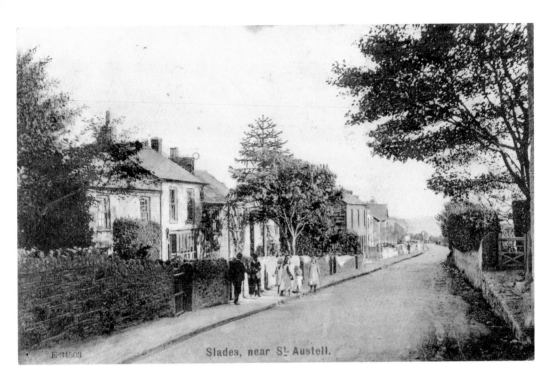

Slades, near St Austell.

Slades

From the crossroads at Mount Charles the road through Slades led to Bugle and Bodmin. The view before the buildings on the right showed the tree-lined gardens at the beginning of the twentieth century in 1907. On the left, half way down the scene, is the shop premises of Warricks. Today this building is still a shop, an advertisement displayed on the gable end.

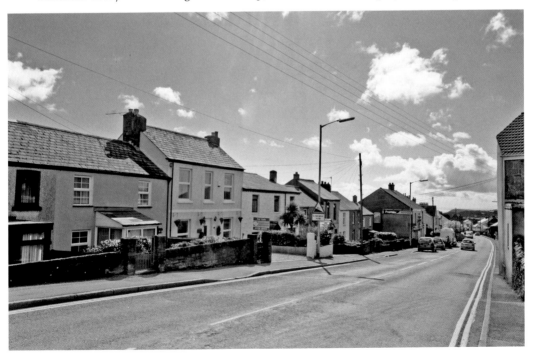

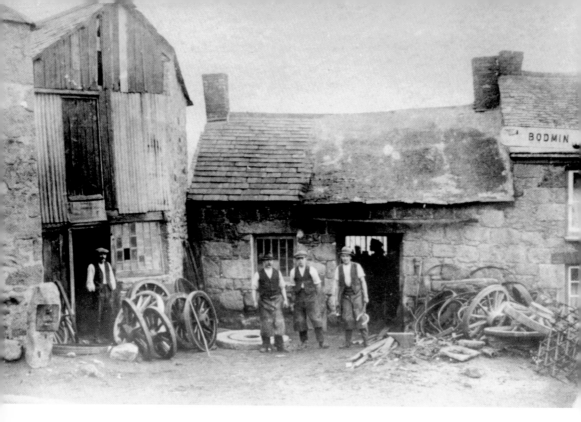

Tregonissey Lane End

At the higher end of Slades Road this forge and wheelwright's business was owned by brothers Charlie and Tom Mitchell. It was a magnificent hive of industry as horses and carts were of paramount importance in the early days of clay transportation. Today the premises only exist in the name on the extension to the end dwelling called 'The Old Forge'.

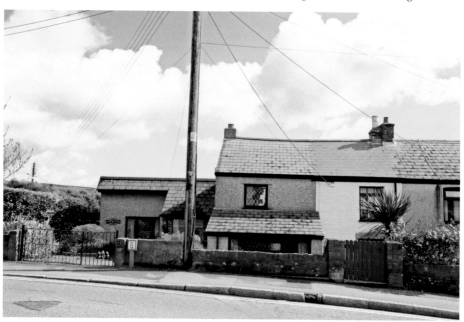

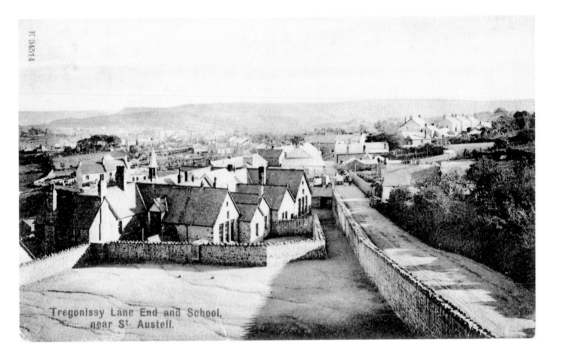

Tregonissy Lane End and School, near St. Austell.

Carclaze School

The Carclaze Board School, built in 1880, was another building designed by the local architect Sylvanus Trevail. Seen here in 1914 the bell tower is visible and the master's house on the end. To date the school is still in use, as the playground illustrates, but after nearly 130 years of education current plans are for a combined infant and junior school on the latter's site.

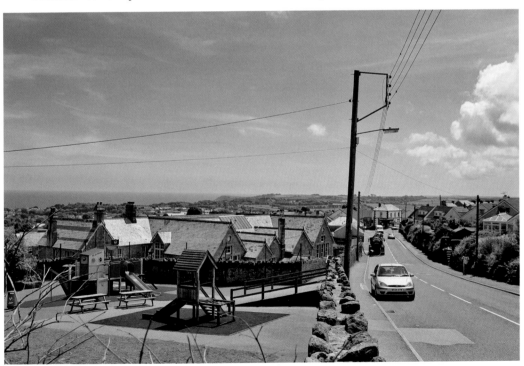

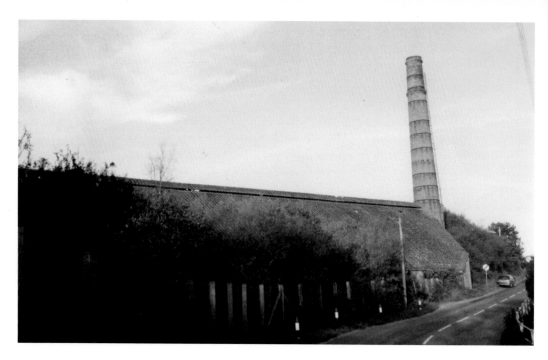

New Development

The clay dry building and stack on Carclaze Road had been disused for nearly forty years since the days of drying the liquid clay on the hot floor to be cut into blocks for transportation to the nearby docks at Charlestown or Par. An amazing transformation in 2006 saw the reconstruction of the site into luxury apartments with magnificent views over St Austell Bay. The roof line of the old dry and the chimney were preserved.

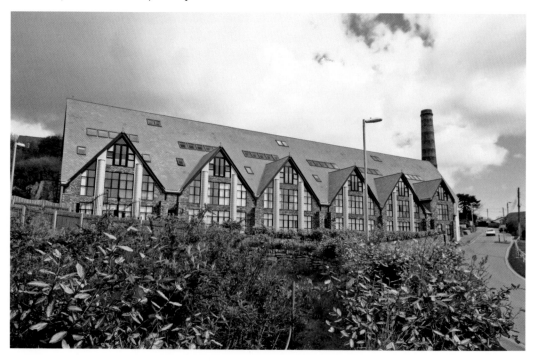

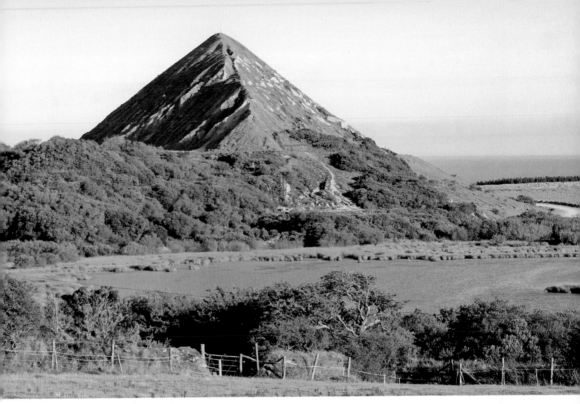

China Clay Tips

A prominent feature on the skyline above St Austell is this pyramid shape of the china clay waste burrow. It is a landmark in the area overlooking a vastness of housing development and St Austell bay, and easily identified from some distance out at sea. When this tip was deposited on the edge of the extraction pit in the late nineteenth century, the conical shape of the sand waste glistened white, giving rise to its local name, the 'Cornish Alps'.

The older scene illustrates the vast workings of the open pit from which the waste had to be hauled after the extraction of the china clay.

The contrast in the two spoil heaps is evident, the one pristine in its early days and the latter mostly covered in vegetation in 2009. The former pit has weathered into a reed surrounded pool.

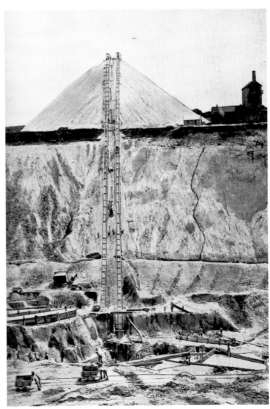

Tregonissey Farm

On the left of this old view are the farm premises of Tregonissey Farm. Once owned by the Duchy of Cornwall it continued to be worked up into the 1960s by the Lewis family. The two women walking by are approaching one of the farm entrances. In 1963, earth-moving equipment began work for the new John Keay House headquarters of the English China Clay Company. The farm was completely demolished in this new development.

Road Widening

Further along Tregonissey Road the full extent of the farm buildings removed can be seen. During the nineteenth century the Kellow family kept many horses for hire, carriage work and extensive stabling facilities supplying relays for the coaches travelling the southern route through Cornwall. The odd shaped house on the far left is the only remaining building in both views.

71

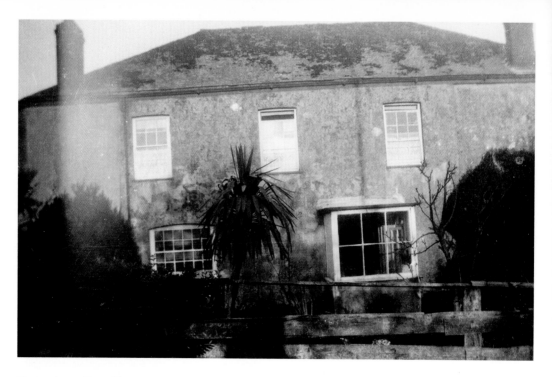

Tregonissey Farm House

Above is a previously unpublished photograph of Tregonissey farmhouse in 1945. The fourteen-roomed house had seven bedrooms and two large reception rooms with a grand staircase. The gardens had huge camellia bushes with orchards of plum, pear and apple trees nearby. The modern view is in sharp contrast where the glass frontage of John Keay House towers over the site of the old farm.

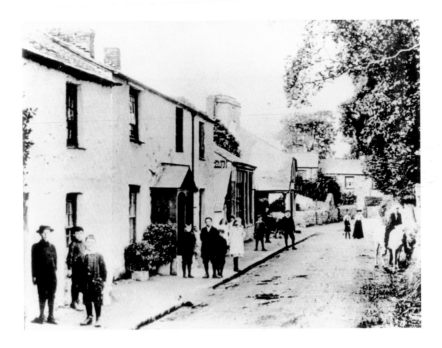

Tregonissey Village

This early scene through Tregonissey village *c.* 1910 shows the road as barely a lane with its hedges and fields of Lostwood on the right overlooking St Austell coastline. A. L. Rowse, author of *A Cornish Childhood*, in 1942 is standing nearest the first porch on the left, with the shop premises where he was born beyond. Unrecognisable as such today, the large cream hip-roofed building marks the site. Only the small cottage in the distance can be identified in the two views.

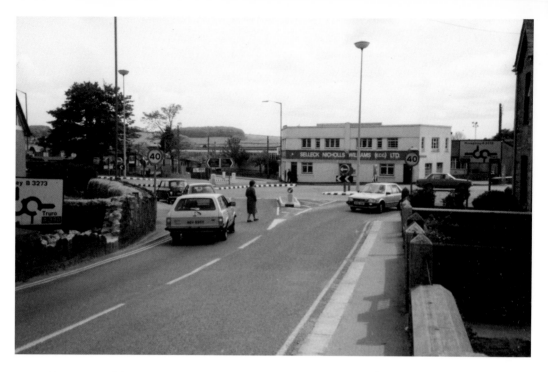

Mevagissey Roundabout

In 1985 the offices of Selleck Nicholls Williams (ECC) Ltd stood on this site on the bypass facing up South Street. During the next decade road traffic schemes employed a triple roundabout system to alleviate modern traffic flow shown in 2009.

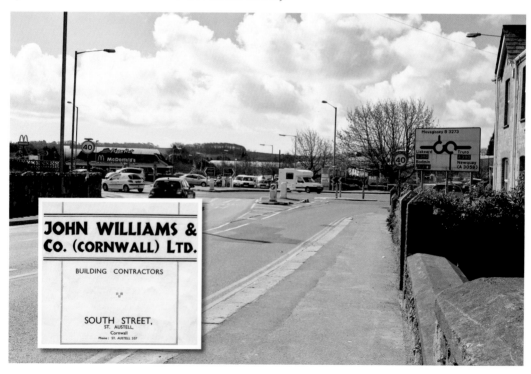

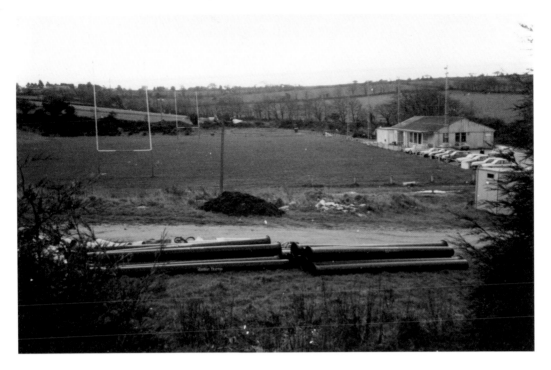

The Bypass

The St Austell bypass has seen many changes since its opening in 1926. The local rugby club played in this field on Cromwell Road sharing its site with the travelling circus when it came to St Austell in the 1950s and 1960s. The elephants walked in single file from the railway station to the field. In 1988 the land was acquired by Asda Stores, a dramatic change of use.

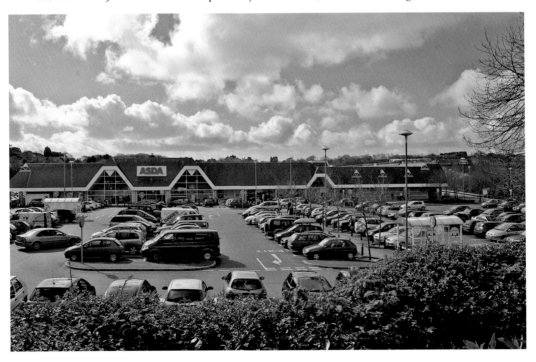

The Roman Catholic Church

Directly opposite Asda and on the junction of Woodland Road and Cromwell Road is the site of the Roman Catholic Church of St Austell. Shown here in 1987 as St Augustine's Catholic church, its members had formerly worshipped in Ranelagh Road, Mount Charles. The new church is a much enlarged and spacious building.

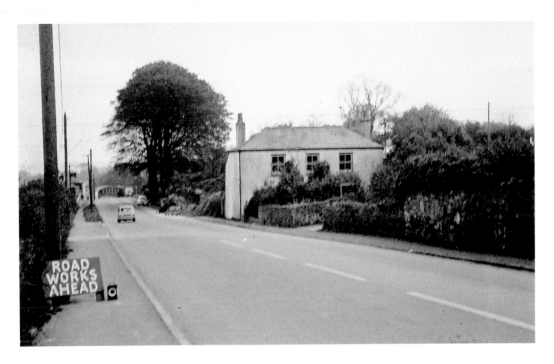

Holmbush Approach

Leading off the bypass and still on the outskirts of Mount Charles, Angle House faced the approach road to Holmbush. New road schemes in this area, however, caused the demolition of Angle House on its triangle of land bordering the Charlestown and Holmbush roads *c.* 1960. The simplistic road furniture, especially the lamp placed alongside the 'Road Works Ahead' sign, is quite amazing. The road lay out was considerably altered, only the railway bridge remaining untouched.

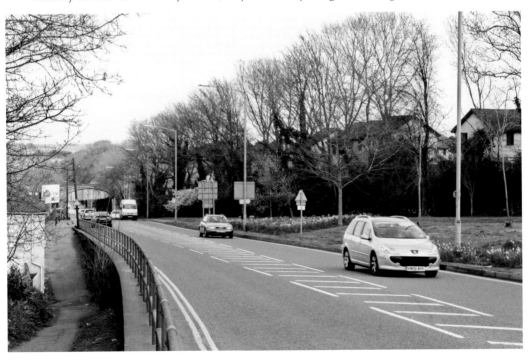

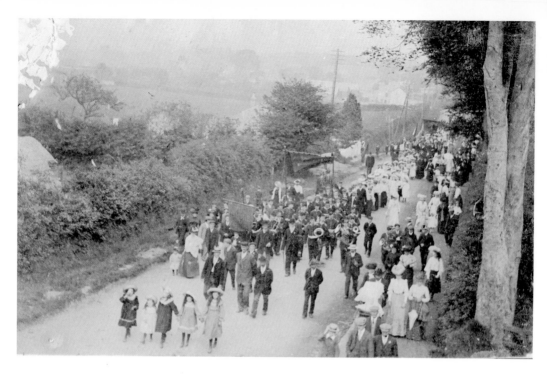

The Parade

This damaged but interesting photograph shows the banners and brass bands leading a Sunday school feast day parade up through Holmbush *c.* 1910. It seems that the band has stopped playing because they are walking uphill. Although the road is empty of pedestrians in the 2009 view, a few of the fine old beech trees still remain on the hedges.

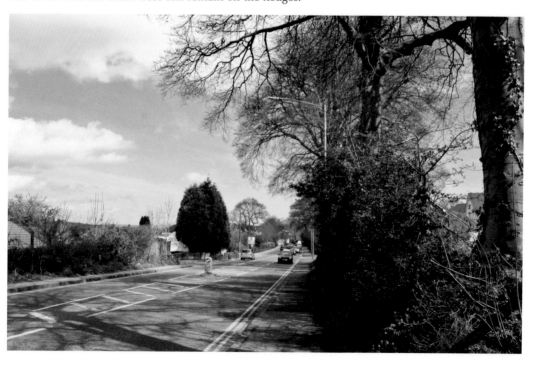

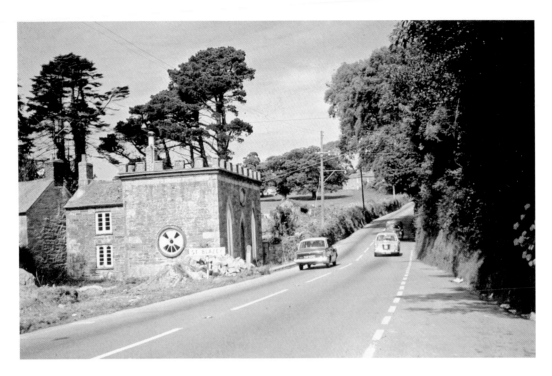

Lodge Hill

The A390 road through Holmbush and on to St Blazey continued to be widened along its route throughout the 1960s and 1970s. At the foot of Lodge Hill, St Blazey Gate, this granite crenallated house survived into the late 1970s and then was demolished for road widening. Only a slight break in the hedge on the recent view indicates where it once stood.

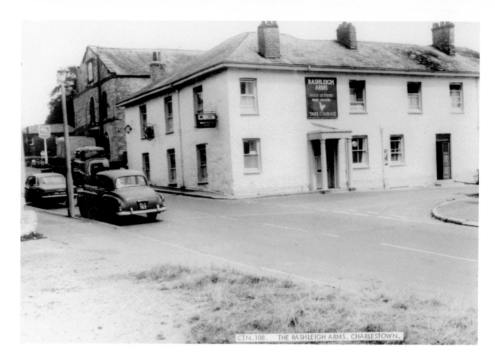

CTN.108. THE RASHLEIGH ARMS, CHARLESTOWN.

Around the Coast

Charlestown, the nearest port and harbour to St Austell, developed from a small fishing village in the eighteenth century to cope with the expanding china clay trade. Early buildings included the Methodist chapel in 1827 and the first hotel, later named the Rashleigh Arms in deference to Charles Rashleigh of Duporth who engineered the building of the fine harbour and inner basin. The same porch is still in use today as entrance to the Rashleigh Arms.

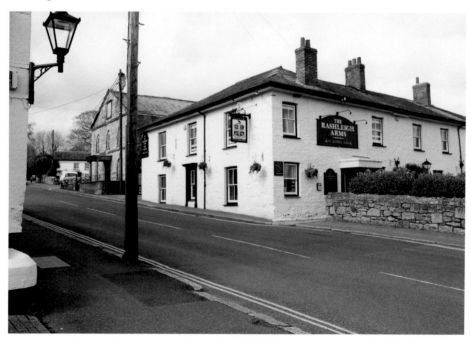

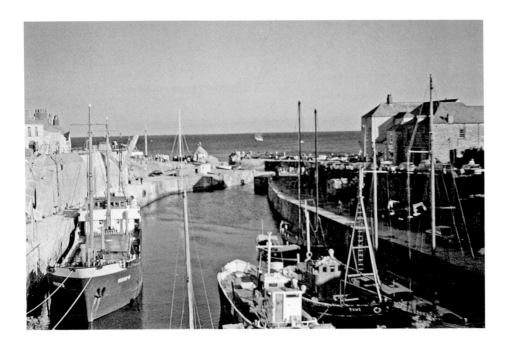

Charlestown Harbour

Both views show the inner basin at Charlestown closed by the metal gates, with bridge over, to contain the water for the vessels within. The older view with the chutes for loading china clay can be seen on the left-hand dock wall. The 2009 photograph looks like an anachronism with the very old sailing vessels on the right but these are owned by Square Sails today for the tourist trade.

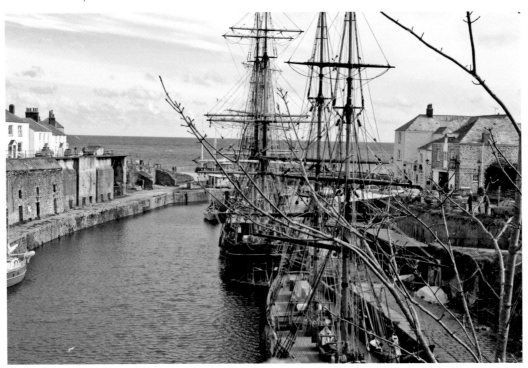

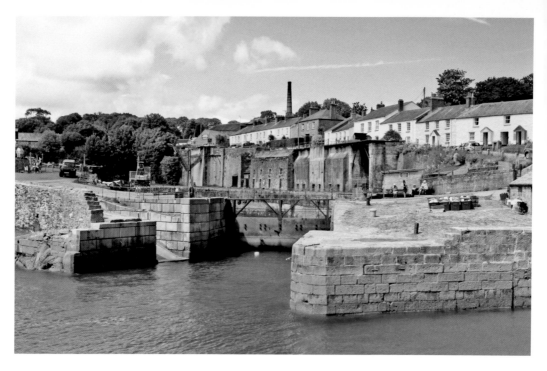

High Tide

The opening of the dock gates always generated much interest in Charlestown. Here a fully laden ship is entering the dock in the 1950s, being carefully manoeuvred through the narrow entrance. The 2009 view is practically unaltered but only one clay chute remains on the far right wall as a feature.

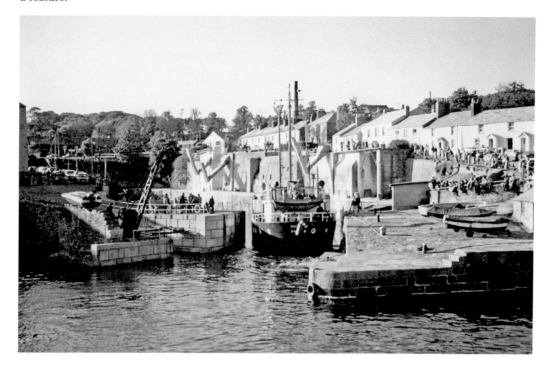

Harbour Entrance

The *Lady Sophia*, a coastal trading vessel, is seen here entering the dock at high tide in the 1950s. The dock gates are opened and recessed into the harbour walls to allow free access from the harbour. They act as a bridge for pedestrians when in position. Gull Rock and Black Head are silhouetted in both views.

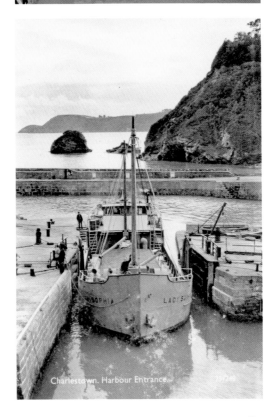

Charlestown. Harbour Entrance

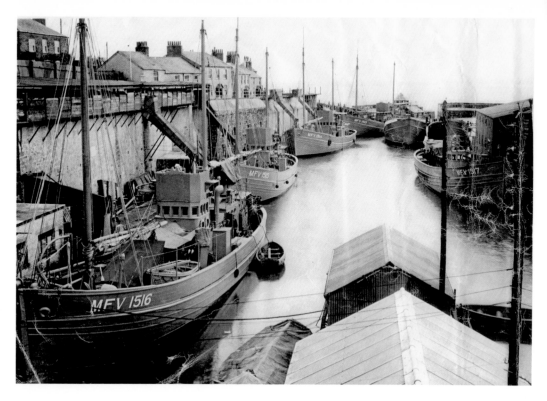

MFV Vessels

Above is a busy dock scene during the Second World War period. The six newly built motor fishing vessels were anchored at Charlestown in the process of being fitted out for the war period. The row of cottages remains unchanged.

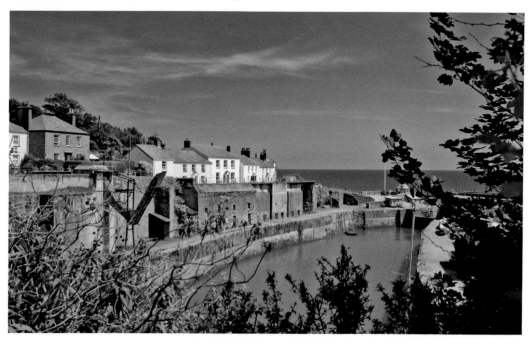

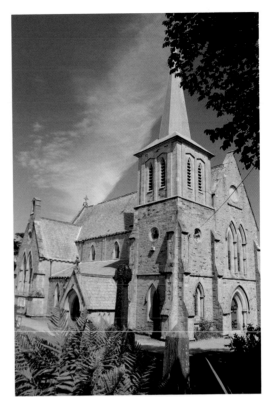

St Paul's Church

Charlestown Parish was formed in 1846 from the larger one of St Austell due to the much-increased population of the area. Built in 1851, the tower of the church remained incomplete until 1971 when a new fibre glass spire was positioned on the tower base by a crane.

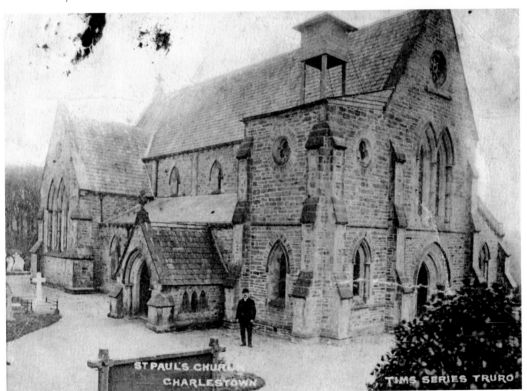

ST PAUL'S CHURCH
CHARLESTOWN

TIMS SERIES TRURO

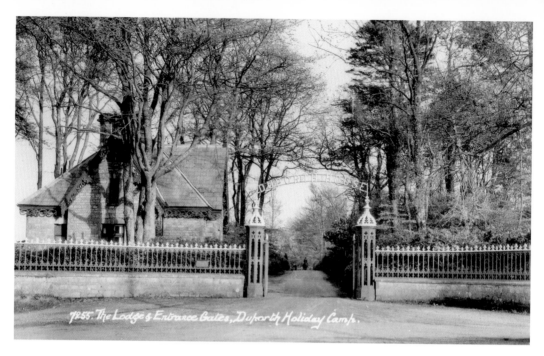

7255. The Lodge & Entrance Gates, Duporth Holiday Camp.

Duporth

Pictured is the Lodge and entrance to Duporth House, built by Charles Rashleigh in the early 1800s, overlooking Charlestown. It was a splendid Georgian residence of Pentewan stone, surrounded by wooded grounds, parkland and terraced gardens (see inset). The house was demolished in 1985, and the whole site was developed for a holiday camp. During the last two years, new ownership is converting the site for residential purposes.

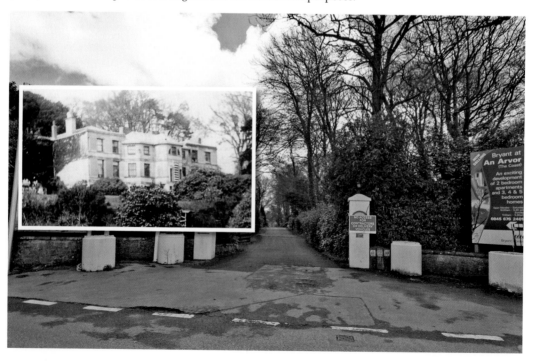

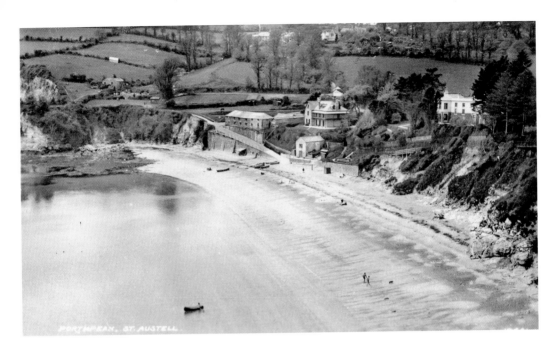

Porthpean

Further along the south coast the next little beach is Porthpean, always popular with the people of St Austell. Porthpean House and grounds on the right overlook the sandy beach. The boathouse is the little building below at the back of the beach. Old buildings above the slipway were the pilchard cellars used by local fishermen. By 2009, the growth from the vantage point only reveals a small part of the beach but with Porthpean Sailing Club premises on the site of the pilchard cellars.

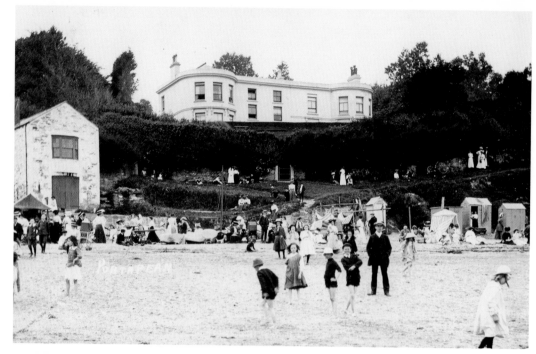

Porthpean House
Porthpean House, the home of the Petherick family for almost 150 years, is an imposing residence on its coastal site. Beach huts and tea facilities were available on the beach seen here at the turn of the century. The Axford family were local boat owners in 1910 and seated here in front of the boat house is Charles Axford.

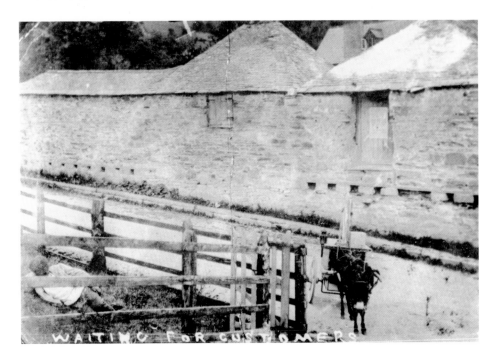

Waiting for Customers

The approach to Porthpean beach was dominated by the extensive buildings of the pilchard cellars. On the slipway in front of the cellars the donkey has brought an early ice-cream cart to Porthpean, accompanied by its owner, a member of the Kelly family seen resting on the grass nearby. The sailing club premises now cover the site of the pilchard cellars with only a lower section of the perimeter wall still extant.

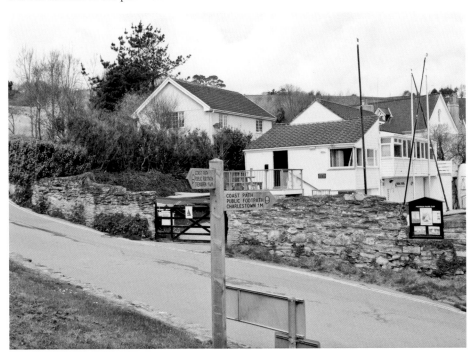

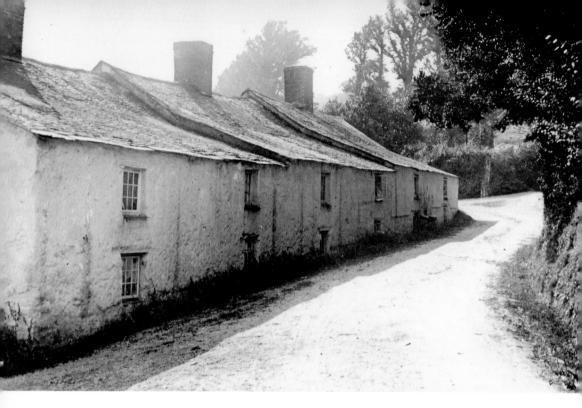

Old Cottages — Porthpean

A very old photograph of fishermen's cottages in Lower Porthpean on the beach corner, long since demolished. Built of cob with roughly slated roofs, they were probably once thatched. Today the site is cleared but a most interesting feature nearby (inset) was the ERII post box reclining elegantly in the subsiding wall and replaced only a few months ago by a free standing one nearby.

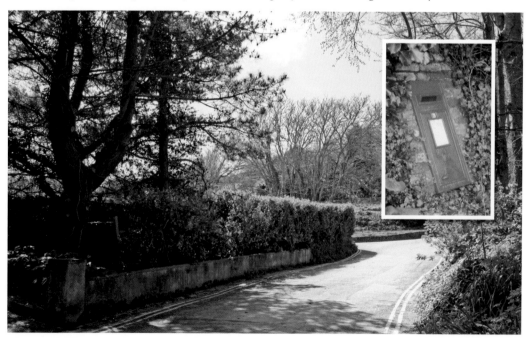

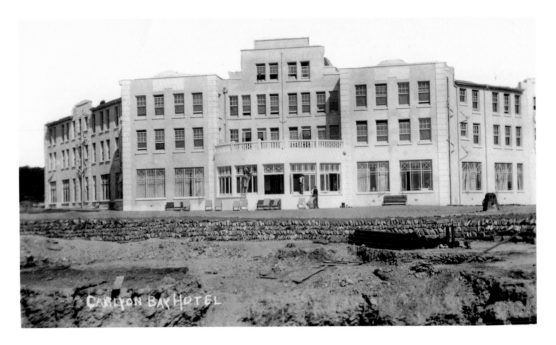

Carlyon Bay Hotel

The new Carlyon Bay Hotel, built in 1930, was a majestic building overlooking the beach at Crinnis and offering luxury accommodation. It had a private golf course nearby and the London trains were met daily at Par Station by hotel staff. On the beach below were indoor sports facilities and an outdoor swimming pool filled with sea water daily for the hotel guests. Today, Virginia creeper covers the frontage and the former beach facilities have been transferred to hotel extensions.

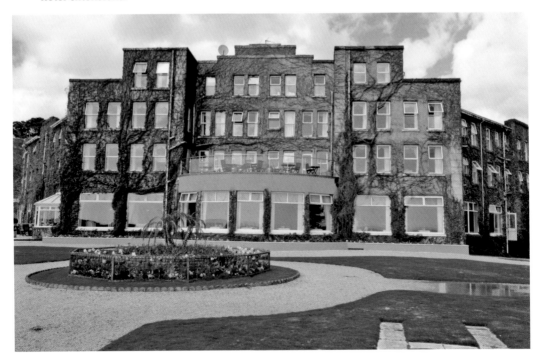

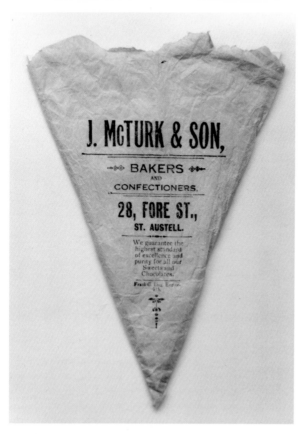

McTurk Bakery

The very old style paper bag used for one ounce of yeast dates from the 1930s when bread making took place several times a week in every Cornish household. The McTurk family business was in Fore Street, St Austell, later transferred to premises at the lower end of Trevarthian Road. An arched entrance led to a cobbled courtyard of the bake house site and is still intact in 2009.

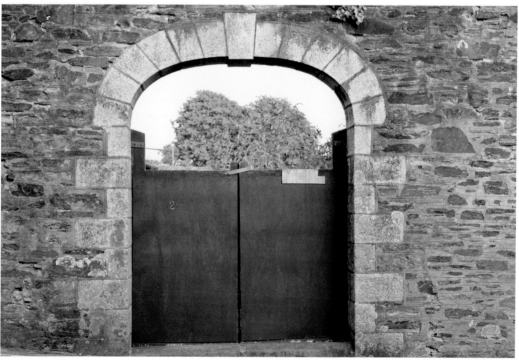

Sign Posts

The white painted triangular granite post in Victoria Road, Mount Charles, dates from the early 1800s and the turnpike era. Penrice was the estate owned by the Sawle family, wealthy landowners in the district and St Austell town. The modern sign post is on East Hill indicating the Eden Project and Heligan Gardens.

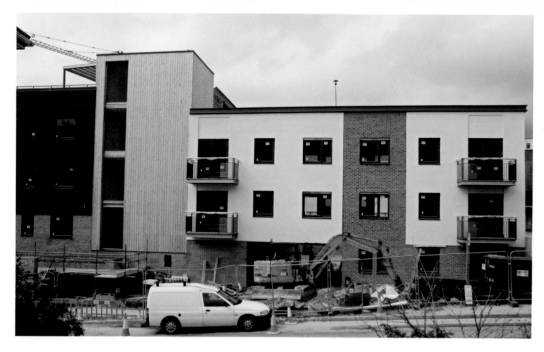

The New St Austell

In the regeneration of St Austell, the project on-going for many years since the turn of this century, new vistas are opening. The brand new White River cinema opened earlier this year, 2009, on Trinity Street. New South Street development replaces a Tesco store and its warehouses, of the 1960s era, with residential apartments.

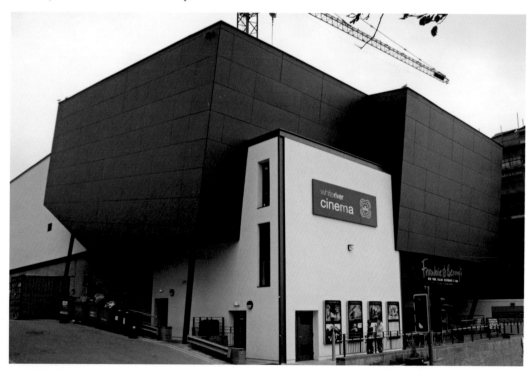

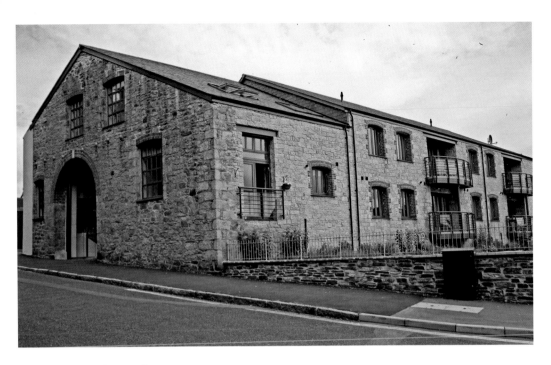

New Housing Projects

In 2008 the main entrance to the old Charlestown foundry was retained as a feature of the old site and was incorporated in a new housing development. In sharp contrast is the modern architecture of Clearwater View, another new housing complex overlooking Sandy Hill and occupied since 2008.

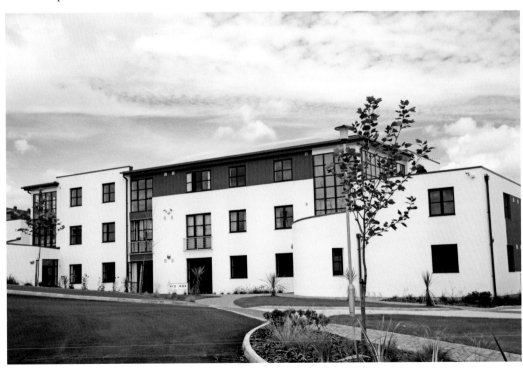

Acknowledgements

This book has meant many shared memories and the glorious lending of photographs.

My main debt of gratitude is to my husband Brian whose encouragement and practical assistance kept me diligently at work. I wish to thank Eric Sandrey who took all the modern photographs with great care and precision.

In my search for photographs of yesteryear, I am most grateful and sincerely thank Sam Edyvean, Mac Waters, Joy Andrew, Phyllis Rowe, Kathleen Caddy, Robert Evans, Barbara Bray and Diana Tregilgas.

Special thanks to my former colleague and friend Carol Folley for putting the captions and text onto a computer file with such patience and expertise.

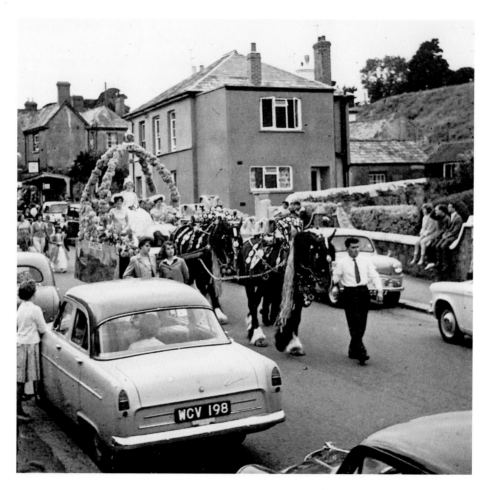

St Austell Carnival
Held at the end of August each year, the St Austell carnival procession — seen here in 1962 — in Alexandra Road was led by two decorated shire horses pulling the carnival queen's float.